A Year in the Life

Glencairn Abbey

Charting the daily lives of the only Cistercian monastery
for women in Ireland

A Year in the Life

Glencairn Abbey

Charting the daily lives of the only Cistercian monastery
for women in Ireland

With photographs by Valerie O'Sullivan

First published in 2017 by Columba Press

23 Merrion Square North, Dublin 2

www.columba.ie

Text copyright © Glencairn Abbey 2017

Photo copyright © Valerie O'Sullivan 2017

ISBN: 978-1-78218-336-5

Cover and book design by Bright Idea, Killarney

Project editor Siobhan Prendergast, Dingle Publishing Services

Photographs by Valerie O'Sullivan

Printed by Gutenberg Press Ltd

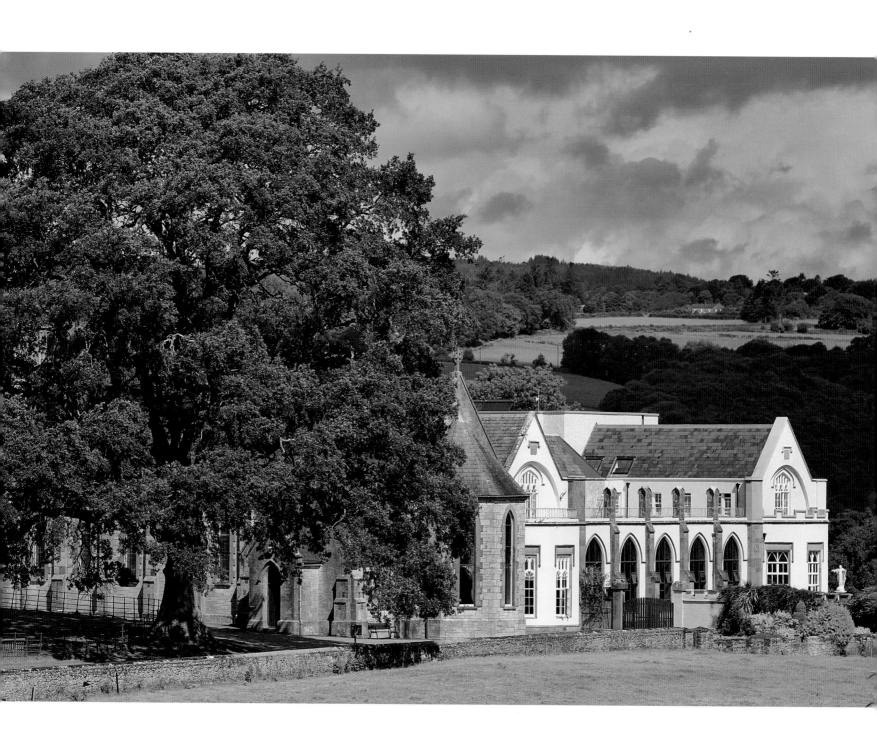

The sisters at Glencairn are called to prayer at 3.50 a.m. for the first office of the day, Vigils, derived from the Latin *vigilia* meaning wakefulness. In darkness when all around are sleeping, the sisters sing psalms, offer prayers and listen to the gospel for all mankind. Their prayer is continuous. The dedication to waking at this hour is selfless. After the office of Vigils, after 5.00 a.m., the community continue in silence for *lectio* either to the Scriptorium or their own sacred space for quiet reading and reflection before breakfast and the second prayer of the day lauds at the break of day. Sr Nuala reads a passage from the Gospel.

FOREWORDS

A YEAR IN THE LIFE OF GLENCAIRN ABBEY

If asked, I reckon most people would associate the lifestyle practices of sustainability, self-sufficiency and mindfulness as very much belonging to the twenty-first century. They are practices we are urged to adopt so as to create a better life for ourselves and those around us.

As it turns out, far from being contemporary, these practices perfectly reflect the rhythm of life at Glencairn Abbey, the only Cistercian monastery for women in Ireland. Based on the *Rule of St Benedict*, whose motto was *ora et labora* (prayer and work), it's a rhythm that has hardly changed since the abbey was first established in 1927.

In this book, daily life through the seasons at Glencairn is beautifully documented by the photography of Valerie O'Sullivan and the testimonies of the sisters who call Glencairn home.

I was particularly taken by the words of Sr Maria Thérèse, who explained why getting up so early in the morning is central to their daily prayer and work. 'Life is good here in Glencairn,' she says. 'We rise at ten to four in the morning for Vigils, a very special time of the day. We keep the whole world in our prayers, especially those who may be suffering, those who can't sleep and those who work at night, those who find it hard to face the new day for whatever reason, those we know and love and those who ask for our prayer.'

There's something very comforting in knowing that no matter what is happening in the world, that seven times a day this community will be there praying for us all.

Hard work, be it in the laundry, kitchen, guest house, sewing room, cardroom, Eucharistic breads bakery or on the farm, makes the community self-sufficient in a sustainable manner.

However, choosing the monastic life does not mean that one is immune to the ups and downs of everyday living as Sr Gertrude explains in her testimony. 'Living with people from different backgrounds, countries and ideas opens one's mind but also means learning tolerance, openness to the sometimes very different views of others and learning to accept and love all sisters.'

So it's no wonder the community at Glencairn has remained strong and two years ago, in a tremendous vote of confidence in the future, embarked on a multi-million euro redevelopment of the abbey and its facilities.

It takes courage and great faith in the future of Glencairn to do this, but courage, faith and a capacity for hard work is something Mother Marie and the community have in spades.

The work undertaken to date has secured Glencairn for another hundred years. It has given the community a great sense of security, joy, identity and hope. But there is more to be done and your support is needed.

However, as Mother Marie says 'growth takes time. We may want to speed things up a bit, but God does not share our compulsion for hasty solutions. The best things in life only mature in, and through, time.'

Anyone who has ever passed through the gates of Glencairn Abbey, know well that as well as the delicious cherry cake, it has something very special to offer. It gives people peace, time to listen to the inner spirit and encouragement when facing difficulty.

To quote Sr Nuala who paraphrased Matthew 17:4, 'Lord, it is good … to be here.'

Mairead Lavery

Mairead Lavery is the editor of *Irish Country Living* at *Irish Farmers Journal* and a regular contributor to Newstalk and TV3 on issues concerning rural Ireland of which she is a great advocate.

I remember a young man once saying to me on a day retreat after a period of quiet prayer, 'I just could not sit still. I have to be doing something'. Sitting still in the quiet presence of the Lord is not part of life for most people today. The signs of this lack of prayer are all around us. When we surround ourselves with activity is it because we need to quieten our restless souls – looking for life outside because there is turmoil within?

In this world full of noise and confusion we must try to not be afraid of our Father God. We need to pray – every day. We need silence to hear His voice whispering peace and showing us gently where we need to go, what we need to do and how we need to change. This will benefit not only ourselves but make us channels of His mercy for others.

The sisters of Glencairn have provided an oasis of prayer and prayerful support since their coming among us in 1932. The abbey, the only female Cistercian abbey in Ireland, is a blessing on this Diocese. The beauty of its surroundings uplifts the heart and the prayer-filled lives of the sisters draw people from all walks of life to visit and perhaps stay.

Now the sisters need our help.

I wish them every blessing and success on their fundraising initiative and I pray that this book will be a significant help not only in raising the funds they need but in spreading their apostolate and knowledge of the way of prayer and work as outlined by St Benedict under the inspiration of the Holy Spirit.

+Phonsie
Alphonsus Cullinan
Bishop of Waterford & Lismore

acknowledgements

The idea of this book came from our friend Valerie O'Sullivan. Her enthusiasm was such that in a short while she had organised a meeting with Garry O'Sullivan from Columba Press. Garry quickly assigned the tasks and responsibilities with deadlines all the way! Valerie would take all the photographs and we would write the texts. Siobhan Prendergast from Dingle Publishing was called in to edit both text and photos and she certainly knew how to keep the project moving forward with skill, accuracy and graciousness. Cathal Cudden from Bright Idea prepared the final design.

We would like to thank this special team for their willingness to embrace our lifestyle and values and produce this book which we dedicate, in gratitude, to all our benefactors and to our Cistercian brothers and sisters.

Thanks to Bishop Phonsie and Mairead Lavery for their kind and supportive words.

Through a series of images and words we get a rare insight into the daily life of the Sisters of St Mary's Abbey in Glencairn, County Waterford. It is the only Cistercian monastery for women in Ireland.

Nestled in the rich heartland of Waterford, they live out their lives through work and prayer, following the *Rule of St Benedict*. There is a mysticism and rhythm to their daily life, which is intertwined with the seasons of nature and liturgies of the year. Their lives are a true, living, monastic journey fulfilling the motto of St Benedict *ora et labora*. (prayer and work)

The friendship and fun I've had with the sisters of Glencairn is an absolute privilege, going back many years of photographing the sisters for different publications. While on a visit to photograph the abbey with Mairead Lavery for the Christmas edition of *Irish Country Living* in 2016, we were informed of the great need of fundraising to complete phase three of their building project. It was afterwards while Sr Sarah and I were chatting about fundraising ideas, that suddenly the notion of a book ensued. Themes and concepts were drawn up. Mother Marie was on board and every member of the community was hijacked into writing their own stories and reflections. Over the past twelve months the visible change of seasons has been compelling and the abbey and its environs have never disappointed, teeming as it does with colour and life. As with nature, the sisters commitment to monastic life is enduring, they work extremely hard. Their lives are truly wholesome and real. We've had a blast, it has been my pleasure to contribute to this book for Glencairn Abbey.

Valerie O'Sullivan
Photographer, Killarney

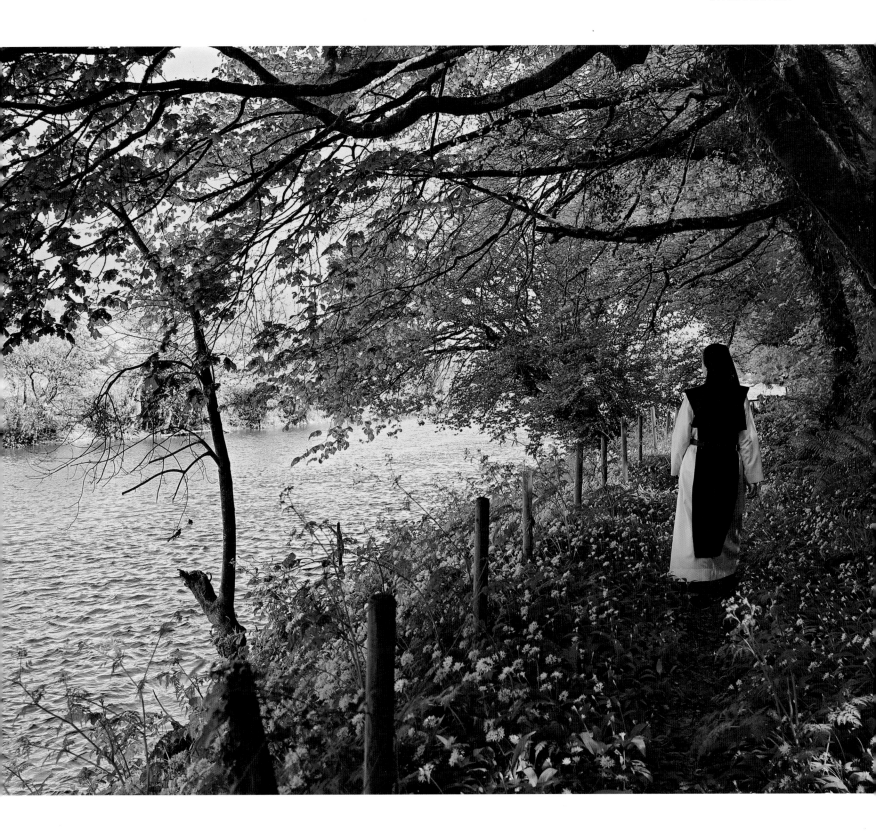

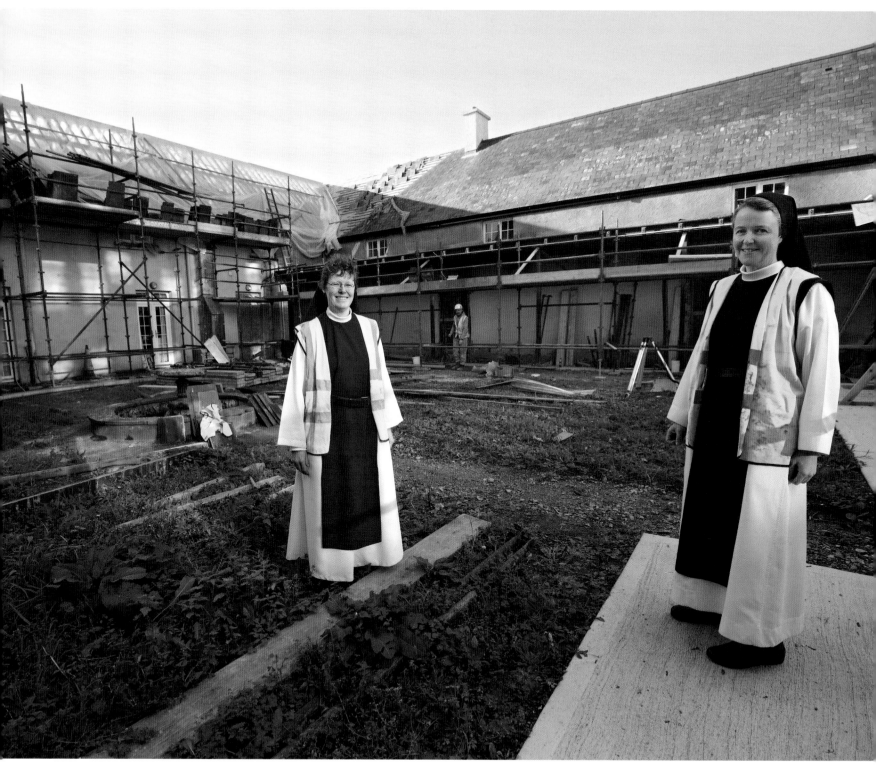

A Year in the Life of Glencairn Abbey is a fundraiser for St Mary's Abbey building project. Founded in 1932, St Mary's Abbey, is the first Cistercian monastery for women in Ireland since the Reformation. Prior to that, the building was in private ownership. During the middle ages, the property formed a portion of the episcopal lands held by the Celtic monks of Lismore. August 2016 saw the completion of the new, much-needed accommodation and refectory area for the community. It was then discovered that the west wing of the monastery, listed buildings of architectural and archaeological significance, were in urgent need of repair. This resulted in the demolition and reconstruction of the west cloister. The south and west wings have been re-roofed and several windows are currently undergoing refurbishment and sensitive conservation. The next phase of works will include new guest accommodation and the provision of a new visitor centre and facilities at the monastery.

Opposite: Sr Michelle and Sr Sarah during the current restoration of their monastery. The roof of the cloisters had been in urgent need of repair, and their living quarters and bedrooms were recently opened after rebuilding, which has cost the abbey over three million euros.

A call to prayer ... Monastic life at Glencairn Abbey calls the sisters to prayer seven times a day. Abbess at Glencairn Mother Marie leads the women to pray at the midday prayer of Sext. Our ancient spiritual heritage is preserved by the sisters of Glencairn Abbey, women who work and pray through silence. They connect our world to heaven, through hours of meditation and creativity. Their life is one of simplicity and order, yet there is a wonderful humanity and kindness that filters from the abbey. We sense their prayers and their unfailing devotion to this life.

Sundays:		Weekdays:	
4:10 a.m.	Vigils	4:10 a.m.	Vigils
7:45 a.m.	Lauds	7:45 a.m.	Lauds
11:00 a.m.	Eucharist	8:10 a.m.	Eucharist
12:40 p.m.	Sext	9:45 a.m.	Terce
3:00 p.m.	None	12:40 p.m.	Sext
6:00 p.m.	Vespers	2:45 p.m.	None
6:30 p.m.	Exposition of the Blessed Sacrament, Benediction	6:00 p.m.	Vespers
7:45 p.m.	Benediction, Compline	7:55 p.m.	Compline

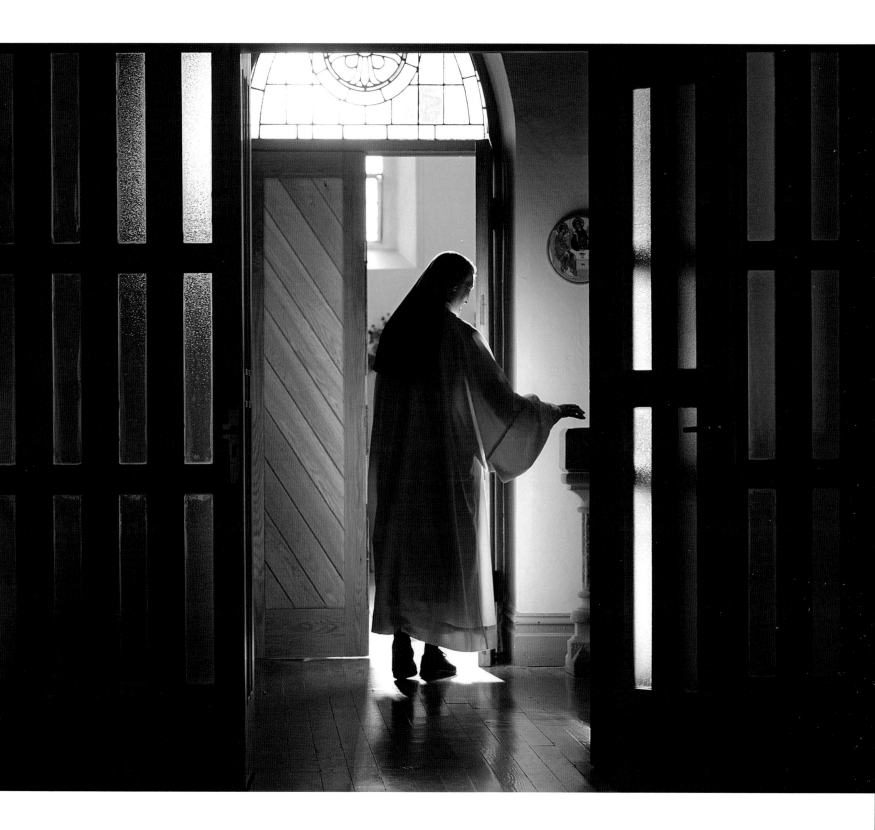

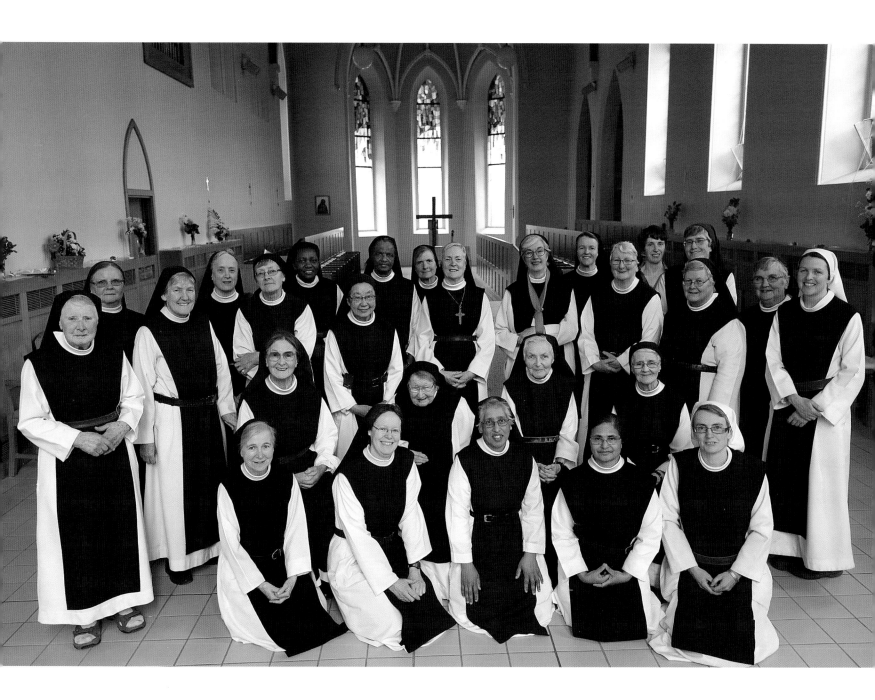

The Glencairn Abbey sisters, gathered for a community photograph at the monastery church, (kneeling front row, left to right) Sr Mary Reidy, Sr Michelle Miller, Sr Stephen Thattil, Sr Robert Kottayil, Sr Liz Deasy, (sitting, middle row, left to right) Sr Gertrude Kelly, Sr Kate Cleary, Sr Agnes O'Shea, Sr Michele Slattery, (standing, third row, left to right) Sr Charlotte McNeill, Sr Mairéad McDonagh, Sr Kathleen Liston, Sr Clothilde Anamizu, Mother Marie Fahy Abbess of Glencairn Abbey, Sr Eleanor Campion, Sr Maria Thérèse Brosnan, Sr Nuala O'Reilly, Sr Angela Finegan, (standing, back row, left to right) Sr Ann Flynn, Sr Josephine Ryan, Sr Anna Bakutala, Sr Scholastica Kallarackal, Sr Denise Vaccaro, Sr Sarah Branigan, Kate Lonergan (postulant) Sr Fiachra Nutty and Sr Lily Scullion.

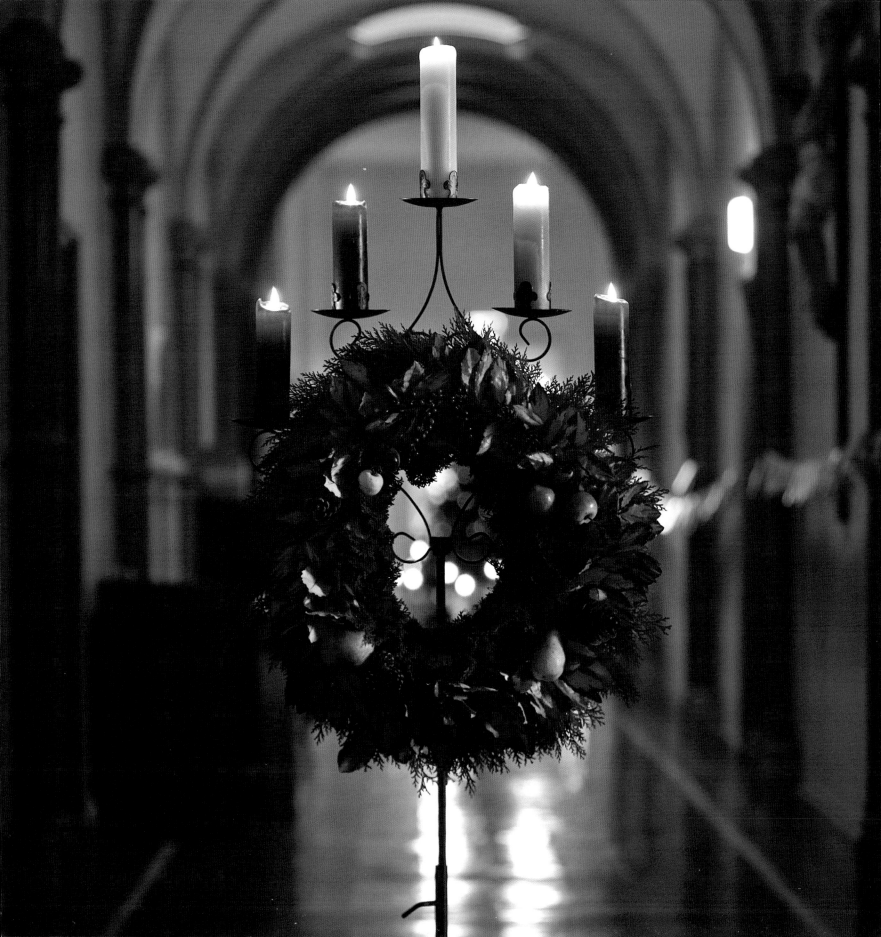

WINTER

Today we begin a new liturgical year, a new season of Advent, a new season of hope. All around us nature is in the dying season, trees are bare, we have long hours of darkness, but with this new season of Advent our hearts are stirred with hope that this year we will allow God to enter more fully into our hearts.

The evergreen foliage is a symbol of hope, the circle is a sign of unending life and the four candles represent the four weeks of Advent, one being lit each week. As the winter darkness deepens, Christ, the true light strengthens and grows until we come to the feast of lights at Christmas when Christ's light dispels all darkness.

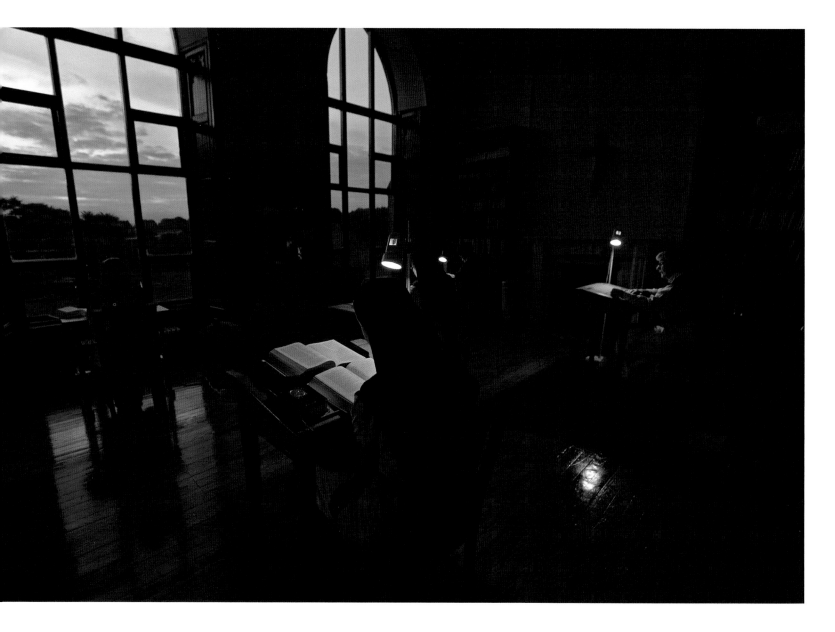

Lectio Divina is a discipline of reading the scriptures in order to listen to the Word of God with the 'Ear of the Heart' to use St Benedict's phrase. Everyday as the dawn comes up, our sisters in formation and their formators do *lectio*, alone but together, in the early morning silence in the Scriptorium. It is an experience of both community and solitude, supporting each other in an ancient monastic practice which leads us to contemplative prayer and praise throughout the day ahead.

Sisters Mairéad and Maria Thérèse printing and arranging sheets of Christmas cards before cutting into individual cards. In the card room at Glencairn we produce quality Christmas cards originally designed by some of our sisters and friends. We also specialise in custom designed memorial cards, bookmarks and appreciation cards using pressed flower images, traditional religious images, nature scenes and individual designs.

Sr Maria Thérèse

Sr Mairéad in conversation with a customer. Sr Mairéad's administrative role within the card room includes taking orders from customers, buying supplies, overseeing the work in the various sections, arranging consignment of goods, etc. She also meets and assists memorial card customers.

Sr Maria Thérèse

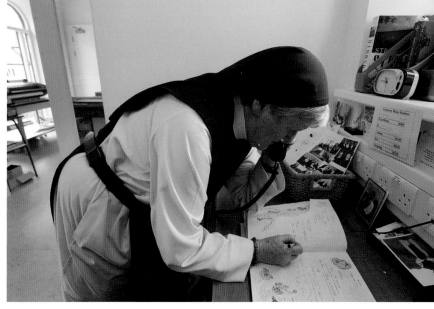

River rising, stretches of pale water on the Inches as whooper swans flying in a great V follow the river course, honking as they fly. Black winter branches filigreed against a white sky. A surprising blackbird orange beak aglow, hops along the mossy, crenellated wall. Crows, rising in a great black circle from a sodden field, wheeling in cold air, cracking the quiet with their cawing, sweep across the sky to finally settle, squabbling, in the top bare branches of an oak. Advent. He is coming – the world waits.

Sr Gertrude

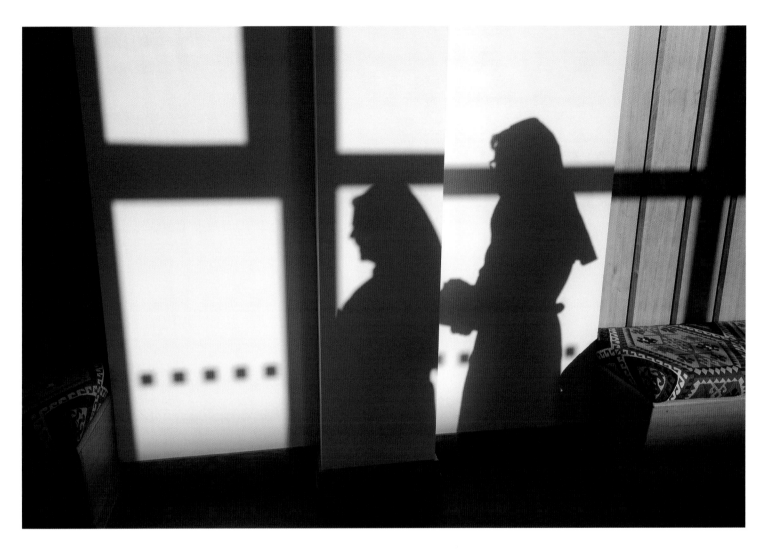

Throughout Advent we reflect on the promises of God to his people. There is one promise underlying all that God does and says, 'I will be with you'. This is God's promise.

Mother Marie

Joy is a hallmark of the Christian life and especially of Cistercian life. Joy springs from the certainty that God is close, He is with us, He is within us, in times of joy and on the down days, in times of sickness and in health, and this joy endures, even in difficulties, in disappointments, in suffering itself. This joy dwells in the depths of each person who entrusts herself or himself to God.

Mother Marie

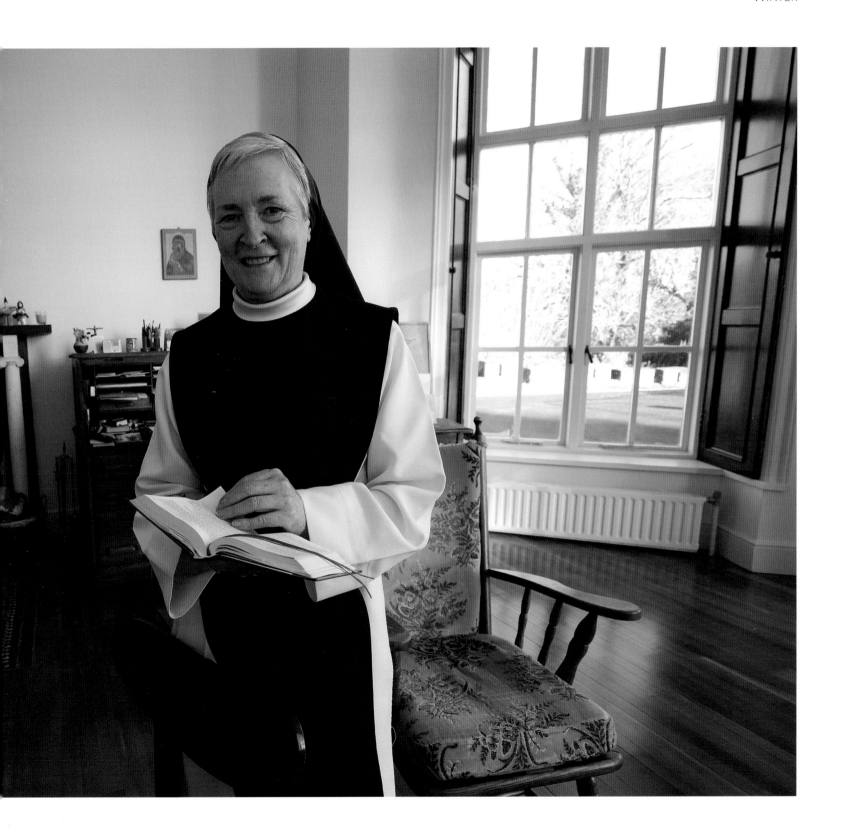

VOCATION STORY

Twenty years ago at the age of twenty-nine I entered Glencairn. My mum hails from County Mayo and trained to be a nurse in London. My father was born in London as was my brother and myself. We moved to Killiney in Dublin when I was five. I grew up in a household dominated by English television, radio and newspapers. My dad is Church of England, while the rest of the family were Roman Catholic.

My life was dominated by a massive love of sport. I played anything, football, badminton, cricket, table tennis, darts and my sport of choice hockey, which I pursued with an unyielding hunger.

I did an Arts degree in Maynooth and would often stray into the theology or psychology section of the library. What gripped me the most were the writings from the early church Fathers, the desert Fathers and the experiences of the mystics. My monastic journey began in England where I first entered the Benedictines at the age of twenty-five. It was there I found out about the Cistercians and the community in Glencairn. After two and half years I returned to Ireland and visited Glencairn. Since entering Glencairn I have experienced opportunity and achievement as well as adversity. (one being the trial of breast cancer) To love God and to be loved by God for me has become more absorbing than anything else.

Sr Michelle

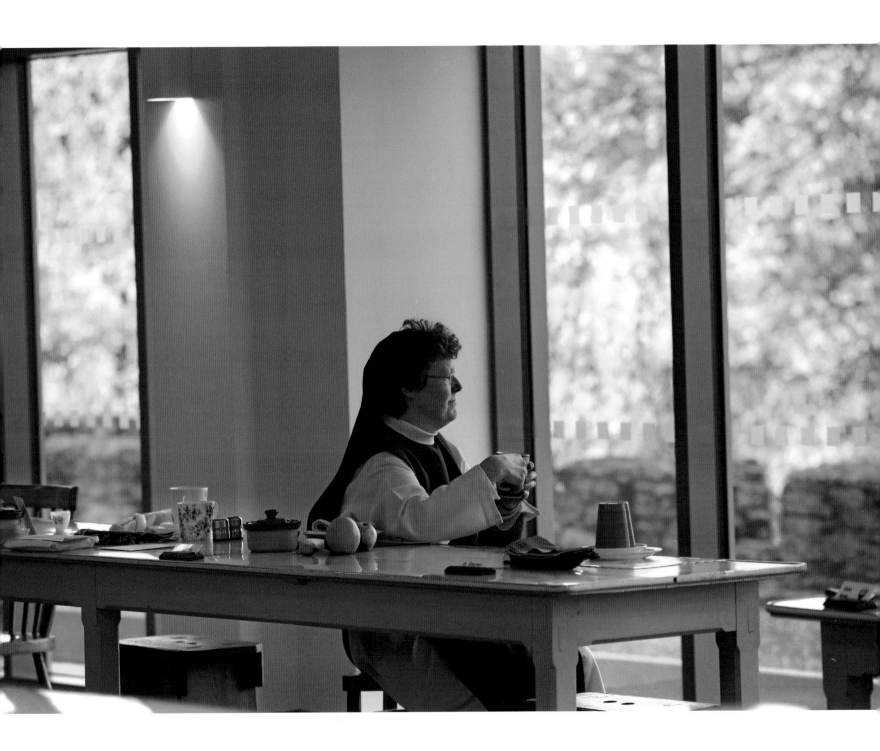

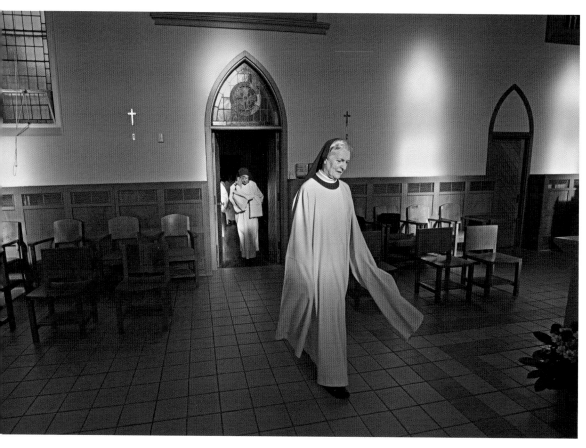

Jesus said, 'I am with you always', and we know that the whole of our monastic journey is a deepening of that union with Christ Jesus. Growth takes time. We may want to speed things up a bit, but God does not share our compulsion for hasty solutions. The best things in life only mature in, and through, time.

Mother Marie

Incense, made from various aromatic resins and gums taken from trees and other plants has been used in the liturgy from earliest times. We use it on Solemnities during Mass to incense the altar, the Book of the Gospels, the crucifix, the celebrant and the people. The smoke from the incense is a symbol of purification and sanctification.

Mother Marie

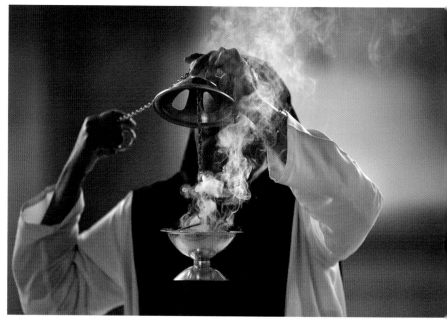

The bell calling the community to prayer at 12:35 p.m. in Glencairn finds nuns hurrying from all parts of the monastery, fields and workshops to gather for the Office of Sext, the fourth liturgical hour of prayer in the day, literally meaning the sixth hour. The community have by this time been up since 3:50 a.m. Three short periods of prayer, Terce, Sext and None, punctuate the working hours of our day, giving structure and rhythm to our life. At Sext we have arrived at the midpoint of the monastic day, a time for rest, *reflection* and renewal.

Sr Sarah

VOCATION STORY

In 1950 my father's only sister entered Glencairn. We first visited her here when I was a child. We were familiar with Dublin, so this rural area was fascinatingly different for us children, and we enjoyed the outdoors while our parents talked to my aunt. The enclosure was strict; our aunt talked to us through a grille in the parlour. So I knew Glencairn from the outside.

As a schoolgirl educated by Dominican Sisters, the thought of being a nun occurred now and then. But by my late teens, after a strict upbringing, I wanted freedom, to travel, a home of my own, children, a life! City life was enjoyable. Dublin was a great place to live. I had a job, friends, many interests, and there was a man in my life, a future. A vocation to religious life was something I very definitely did not want. Yet God called me, quietly at first, then more insistently and finally very clearly. His call was to the contemplative life in Glencairn. I had no doubt about that. Finally I gave in, though I kept finding excuses to delay entering the monastery. Eventually, afraid of absolutely refusing God, I very reluctantly entered where He wanted me. Some of the few people who knew of my decision strongly disapproved. I still hadn't told the man who mattered most to me.

Even now, over fifty years later, I still miss Dublin, but I've grown to appreciate and love living in our beautiful place. Loving the place and the sisters is part of the Cistercian charism. It has not been easy, but what life is? Before the changes brought about by Vatican II, Cistercian life was very tough, but those changes have encouraged a vibrant and caring community life; we know each other now in a way that was not previously possible. Self-knowledge is an essential part of religious life. Living with people from different backgrounds, countries and ideas opens one's mind but also means learning tolerance, openness to the sometimes very different views of others, learning to accept and to love all sisters. And the essential, drawing nearer to the Lord, day by day. Joys and sorrows, ups and downs, over fifty years of it.

So ... Was it worth it? YES YES YES

Sr Gertrude

Sr Gertrude is the devoted librarian and archivist at Glencairn Abbey. She has spent hours and years documenting books, photographs and all manner of artefacts pertaining to monastic life. This impressive library has been her pride and joy for over fifty years.

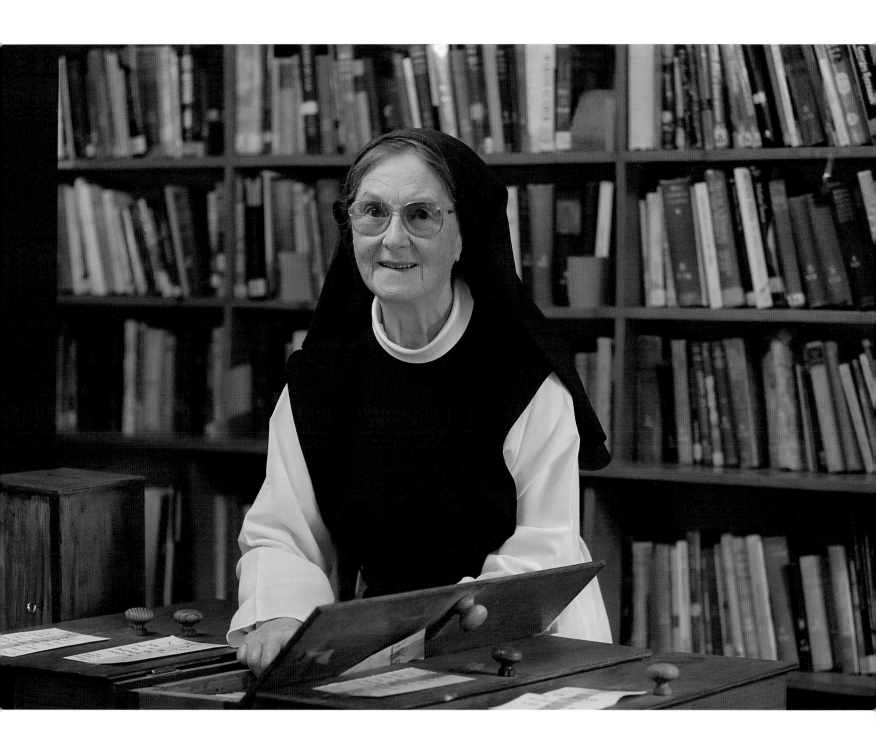

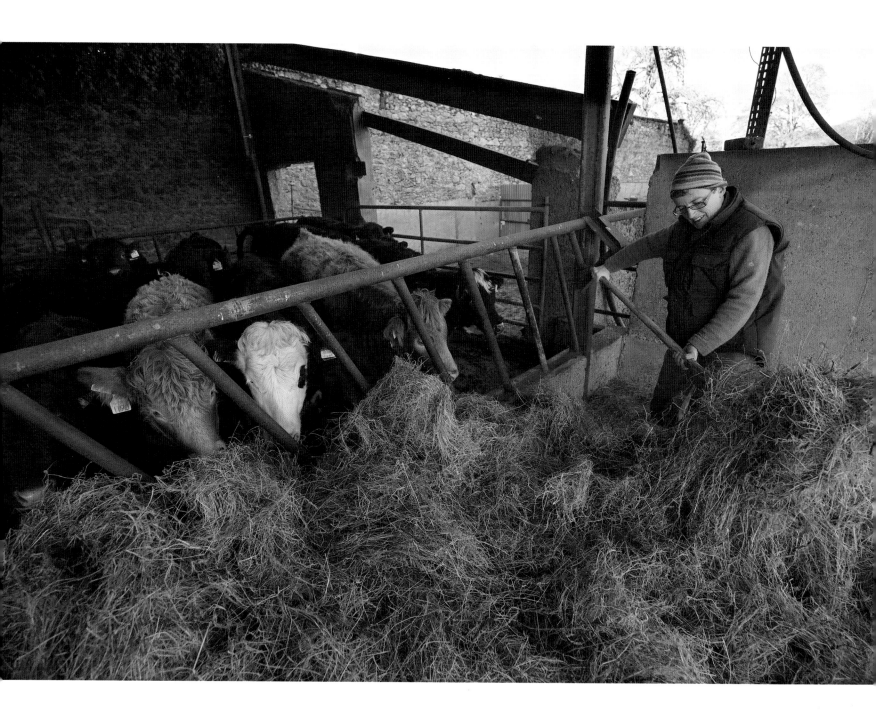

VOCATION STORY

I entered Glencairn on the Feast of the Epiphany 2013 at forty years of age. Obviously mine was a late vocation, though in truth God had been calling for a long time.

After college I worked in IT, but my life felt empty, and then in one sudden moment I knew that God adored me. I began to pray and read and go to daily Mass and frequent confession. I had never visited a convent or monastery but was familiar with Mount Melleray Abbey from hill walking in the area and knew that they would know the nuns too, so I went there to see. There I saw ordinary men praising God together as best they could and I thought, 'I could do this'. It was my 'Yes'.

I visited Glencairn and was attracted by the Divine Office, the balance of the life, work and prayer, the beauty of the place and the kindness of the sisters. There they had a real purpose in praising God and praying for the world. I'd already procrastinated enough and knew I was coming. It was all grace.

Giving up the work on which I had depended for so long for security was surprisingly easy. I had no idea what I would do if it didn't work out, but I knew I couldn't go back to my old life. My family and friends were supportive – once they got over the bombshell, as Mama called it. Needless to say, they didn't see me as someone who'd join the nuns – any more than I did.

Sr Liz

Left: The early Cistercians share with us their mystical insights through their writings and sermons. Their spirituality was deeply rooted in, and shaped by, the Scriptures. The Word of God was their spiritual food and drink, and filled their minds and hearts throughout the monastic day, ever deepening their devotion to Christ.

Below: It is Christ's peace that we share when we turn to each other at the Mass and exchange a 'pax', an embrace of peace, followed by a gentle bow to one another. *Pax* is the Benedictine motto; it is St Benedict who shows us the way to Christ through his *Rule of St Benedict*. At the Eucharist, we celebrate and are strengthened in our communion in Christ as a monastic community.

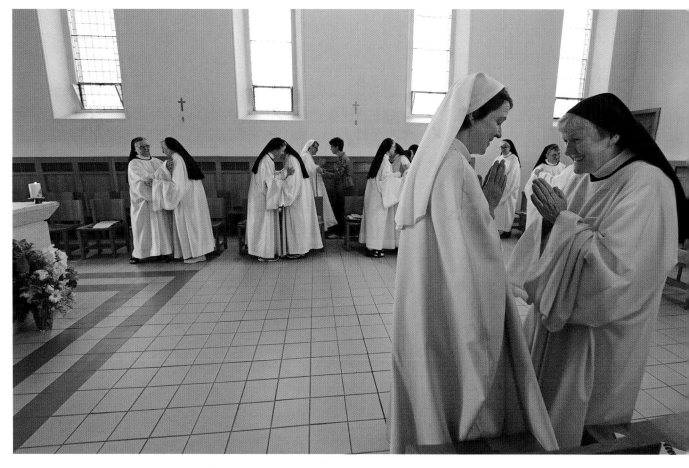

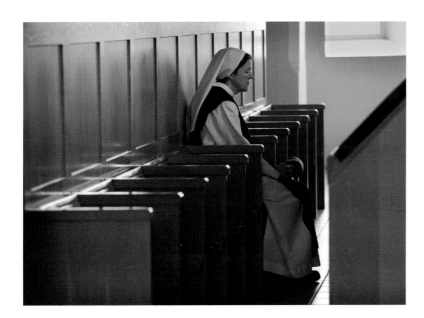

Sr Angela sits in silent prayer. Constant talk and chatter and noise are detrimental to any kind of prayer and contemplation. We can be gracious and kind and loving without words. We can be quiet and give ourselves to *lectio* and prayer and silence.

Mother Marie

When clothed in the Cistercian habit the novice receives the white veil. It is always a bit of a shock to wear a veil! She wears this white veil until she makes solemn profession when she becomes a fully professed member of the Glencairn community and of the worldwide Cistercian Order.

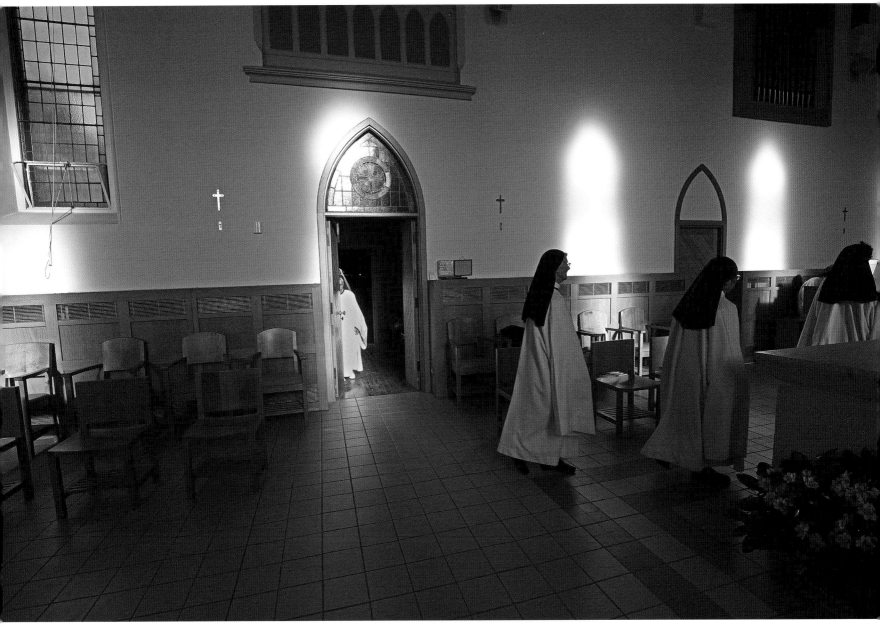

All of us, moved by grace and the touch of God have accepted to follow that call to deep intimacy with God by following Christ in his obedience and prayer, to live at times in the darkness of faith and accepting the consequences of our choice. Attentive to our own personal transformation we seek to cultivate attitudes, speak words and engage in actions that witness to our faith in the Incarnation – God with us, in us, who comes to others through us.

Mother Marie

The psalter is at the centre of liturgical worship at Glencairn Abbey. The calligraphy for the psalter was lovingly written by Dr Margaret Daly-Denton, who is a scripture scholar, an organist and internationally published composer of church music.

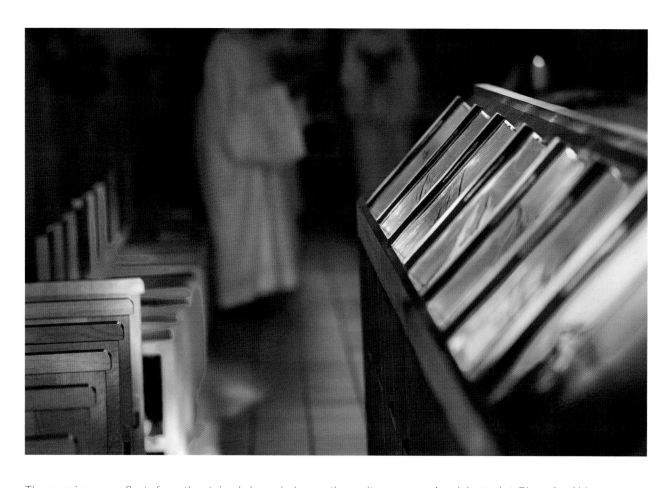

The morning sun reflects from the stained glass window on the psalters as mass is celebrated at Glencairn Abbey.

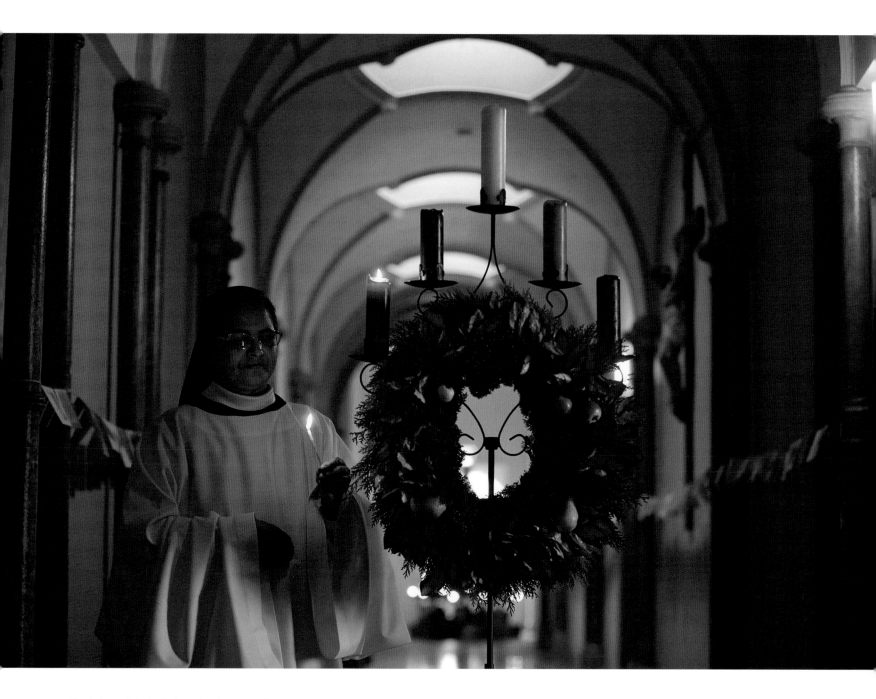

Sr Robert Maria lights the first candle on the Advent wreath. The Advent wreath stands as the centrepiece in the abbey church during this season in preparation for Christmas. Skillfully wrought by Sr Fiachra, its five candles are like beacons lighting the way to Christmas, its circle of evergreen leaves signifying eternal life.

Sr Sarah

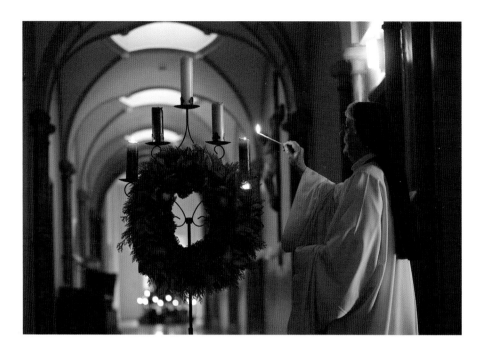

Sr Maria Thérèse lights the second candle on the Advent wreath. Advent comes from the latin word *Adventus* which means coming. Our longing for Christ is expressed in the liturgical prayer of the Church and in our personal prayer. In the hours of winter darkness of this holy season, the church is filled with the stillness of expectation.

Sr Sarah

Sr Sarah lights the third candle on the Advent wreath. The third candle on the Advent wreath is rose-coloured and is lit on Gaudate Sunday, the third Sunday of Advent. Gaudate means rejoice. Entering the final phase of preparation for Christmas, our waiting now gives way to joyful hope.

Sr Sarah

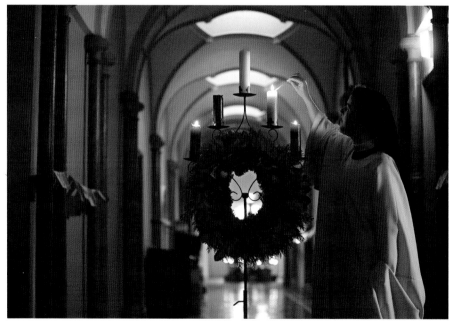

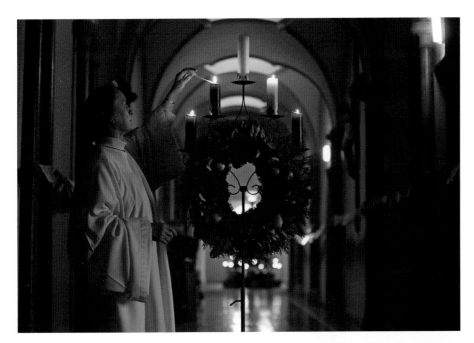

Sr Josephine lights the fourth candle on the Advent wreath. The liturgy in the final week of Advent meditates on the mystery of Christ's nativity. The special role of Mary in salvation history is highlighted, foretold by the prophet Isaiah, 'the maiden is with child and will soon give birth to a son whom she will call Immanuel'. (Isaiah 7:14) Immanuel means 'God is with us'.

Sr Sarah

Sr Angela lights the fifth candle at first Vespers of Christmas. The symbolism of light goes back to the pre-Christian winter solstice festival, the date on which the sun, at its weakest, begins to revive and grow stronger and brighter. Christmas then is truly a feast of light and the Advent wreath has completed its journey to the Light of lights.

Sr Sarah

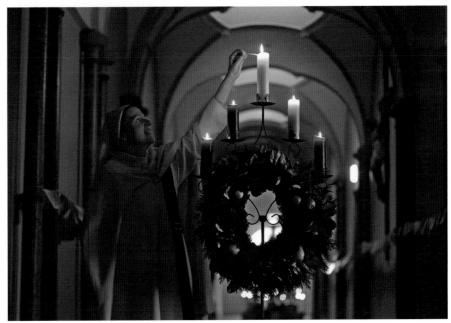

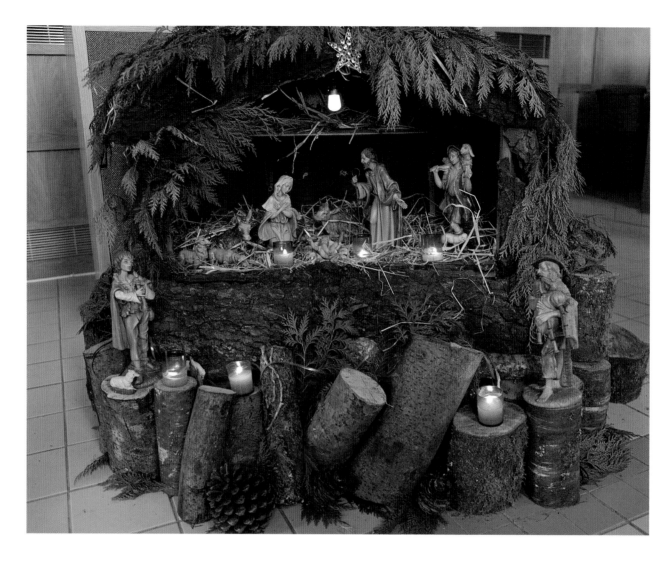

Apart from the figures, the crib is made from the fruits of the earth, including logs and bark from the woods, straw from the barley harvest and palm branches from which a lovely fragrance arises. The sisters in initial formation use their own creativity to assemble the crib. In the afternoon of Christmas Eve the finishing touches to our Christmas crib are made. It is the tradition in Glencairn, that the last person that has entered the monastery is given the honour of removing the infant Jesus from the centre of the altar and placing Him in the manger. This ceremony takes place before the beginning of Christmas Eve Mass whilst the community and people sing in praise and adoration, 'Come let us adore Him'. Our celebration of this Eucharist and the singing of carols at the end of Mass draws people from the wider community to the monastery. Although it takes place at midnight, the church is always packed and it is a festive and joyful occasion.

Sr Nuala

On Christmas Eve we are all busy with final preparations. By 4.45 in the afternoon we are all assembled in choir and really getting into the spirit of Christmas. The whole atmosphere is charged with the feeling of the coming of Christ. The two bells ring out that Christmas Eve is here. It is time for the first Vespers of Christmas, which begins with the hymn, 'A noble flower of Judah'. It's a beautiful hymn, sung in four parts. The text for this hymn comes from the fifteenth century *Es ist ein' Ros' entsprugen* and the music is from Alte Katholische Geistliche Kirchengesang 1599.

Sr Agnes

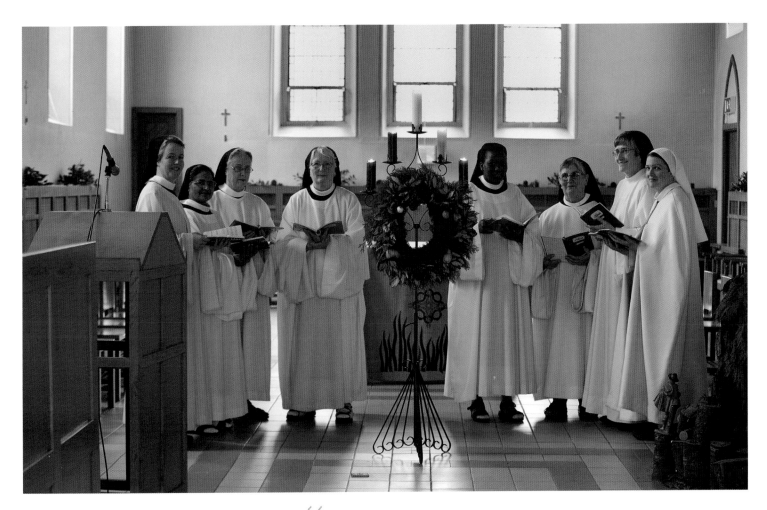

"
A noble flower of Judah
from tender roots has sprung,
A rose from stem of Jesse,
as prophets long had sung,
A blossom fair and bright
That in the midst of Winter
will change to dawn our night.
"

VOCATION STORY

My vocational journey was long and arduous, full of unforeseen twists and turns. My first awareness of a vocational call to religious life came when I was sixteen years old. I had a profound spiritual experience in a church where I had often attended Mass, one that was to change the direction of my life. When I left school I trained in general nursing in Glasgow, followed by midwifery training in Dublin. Once I had finished my training I entered a nursing and teaching congregation called the Franciscan Minoresses, whose founder was from Ireland, where I spent just over four years.

While there I had a second profound spiritual experience, occurring again in a church. Completely out of the blue I heard what seemed to me an inner voice of Jesus telling me that this was not the place for me. After two years of inner turmoil I finally made the decision to leave the Franciscans.

I decided shortly afterwards to go to night school to study maths. It was during this time that I first visited Glencairn and did various monastic live-in experiences here. At the beginning of the summer of 1985, I completed my MA in mathematics and by the end of that summer I had entered the Cistercian community of St Mary's Abbey, Glencairn.

The reasons for wanting to be a religious are, first, to be a person of deep prayer and second, to be a warm, loving, and caring person. Glencairn is a sacred place with a real community, where I have put down my roots and continue to blossom, a holy place and a genuine loving community where I can continue to grow into the image and likeness of Christ until God calls me to my final sacred place from which I came, namely God Himself.

'Lord it is good … to be here.' (Matthew 17:4)

Sr Nuala

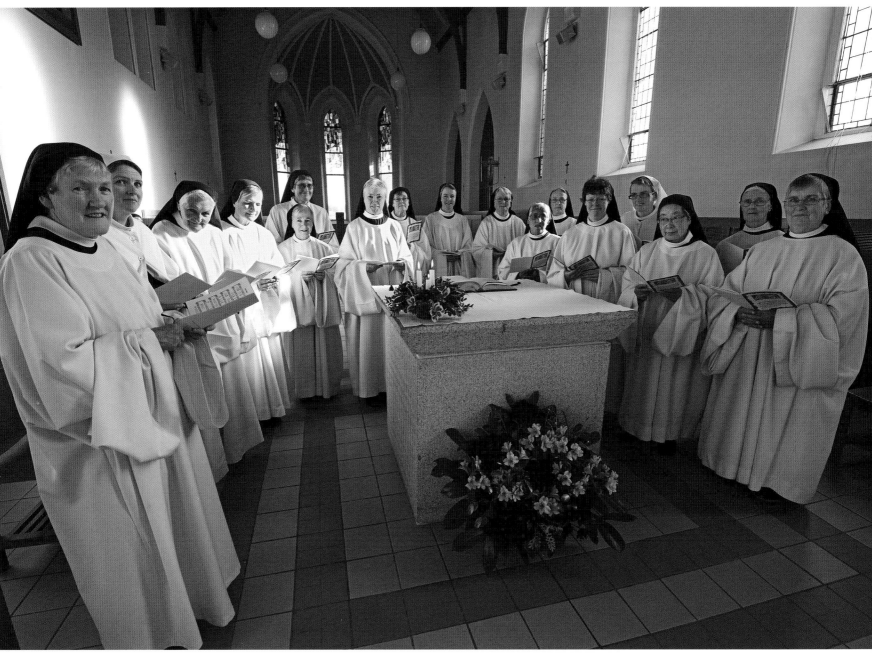

The choir practise Christmas hymns for midnight Mass, which is a much-anticipated celebration in County Waterford. (from left) Sisters Mairéad, Angela, Agnes, Denise, Mary, Fiachra, Marie, Kathleen, Sarah, Maria Thérèse, Stephen, Josephine, Michelle, Liz, Clothilde, Michele and Lily.

" This is the day the LORD has made;
Let us be glad and rejoice in it. "

(Psalm 118)

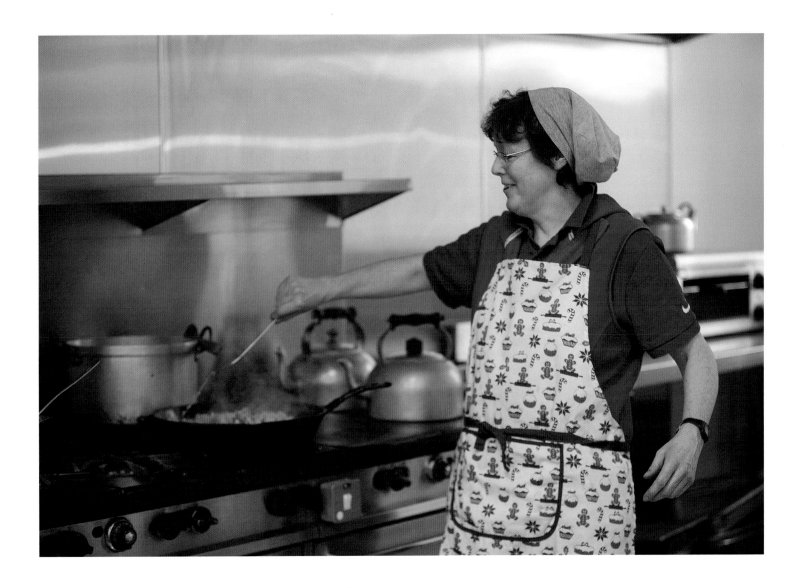

This is our first Christmas in our newly-built accommodation. The builders have gone on their Christmas break. The cleaning, the polishing and the dusting are finished. The Christmas decorations, the holly, the strings of Christmas cards and the crib capture the Christmas spirit, and the Christmas tree with its colourful lights and glittering ornaments illuminate the cloister.

On Christmas morning we silently descend the stairs for breakfast, rubbing the sleep from our eyes after only a few hours in bed following the midnight Mass. We were slow to get to our beds afterwards as we were soaking in the joyful atmosphere of the night, following our nightcap of tea and mince pies. The refectory is colourfully decorated with brightly lit candles that change colour by a remote control device! Little gifts are on each sisters' place in the refectory. Our housekeeper, Sr Michelle, has tastefully produced an array of breakfast cereals, yoghurts, fruit, etc. from the gift hampers filled with all kinds of food and drink with which our generous neighbours, friends and relatives have provided us.

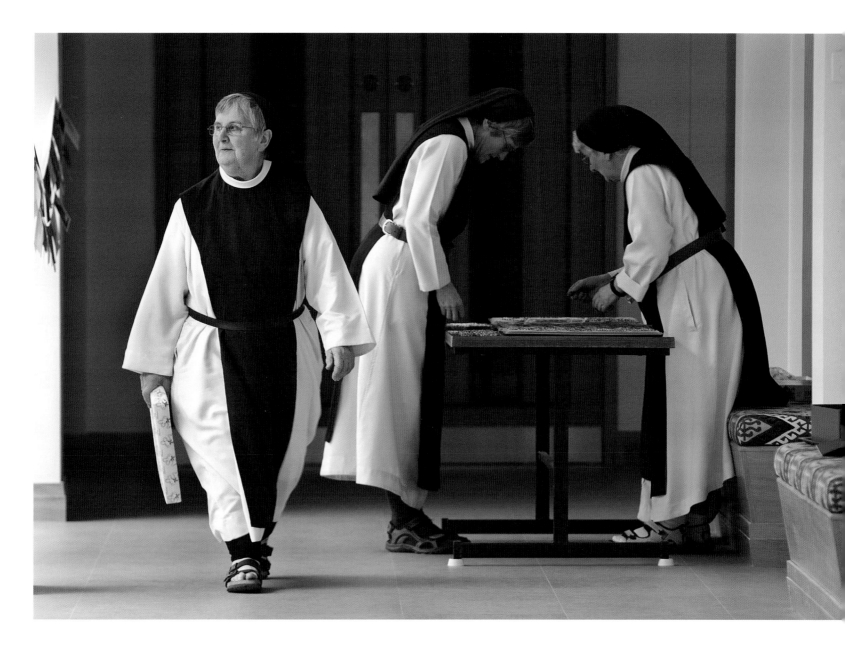

Following our morning praise and prayer at Lauds we gather in the Abbess's room to wish one another a happy Christmas and celebrate with Christmas cake and other delicacies. The Abbess gives each individual sister a present, wrapped in colourful Christmas paper. I tear the paper expectantly, what will it be this year? Another pair of slippers! I will soon end up like Imelda Marcos! We also receive individual gifts from some kind neighbours. We exchange and share with one another,

calling to mind God's gift of a Saviour to humankind. There is great excitement, warmth and camaraderie. Happiness is meant to be shared. This giving of gifts evokes many memories of Christmas past for me. It is the simple things in life that create the memories that stay with us forever.

The smell of turkey and ham wafts in from the kitchen. Sisters Anna and Nuala are the cooks this year so we are expecting a great

feast. Some of us help with the preparation of the vegetables while Christmas carols play in the background. Every now and again during the morning we make a quick visit to the crib to wish baby Jesus a happy birthday. It is everybody's birthday today, the newborn Saviour came to bring us new life. I celebrate my own rebirth and pray for the Prince of Peace to bring peace to our troubled world.

At 11 a.m. it is time for Mass. We joyfully sing, 'Today a Saviour has been born to us. He is Christ the Lord'. Many children with their parents attend this Mass and visit the crib. The Abbess welcomes them and distributes some sweets.

A festive meal awaits us following midday prayer. We normally eat in silence, but today we have a 'talking meal'. It is one of the rare occasions that we have meat, so our senses of smell and taste are well satisfied. We have stuffed roast turkey and glazed roast ham with all the trimmings. For dessert we have plum pudding, trifles galore, as well as succulent chocolates, cakes and other goodies baked by our regular cook Liz and Sr Michelle. I believe that there is a time for fasting and a time for feasting. The sacred season of Advent is over and this is the time for feasting.

In our grace before meals we pray that the joys of this Christmas Day may be for us a foretaste of the eternal joys of heaven. The dinner lasts a long time – we seem to have forgotten the art of eating and speaking at the same time! We pull the Christmas crackers – BANG! There is much laughter and merriment at the silly jokes, it must be the effect of the wine that some of us enjoy! 'What did the piebald cow say during the frost? I'm Friesian.' Sr Lily enjoyed that one!

After dinner some of us watch a DVD film, the more energetic go

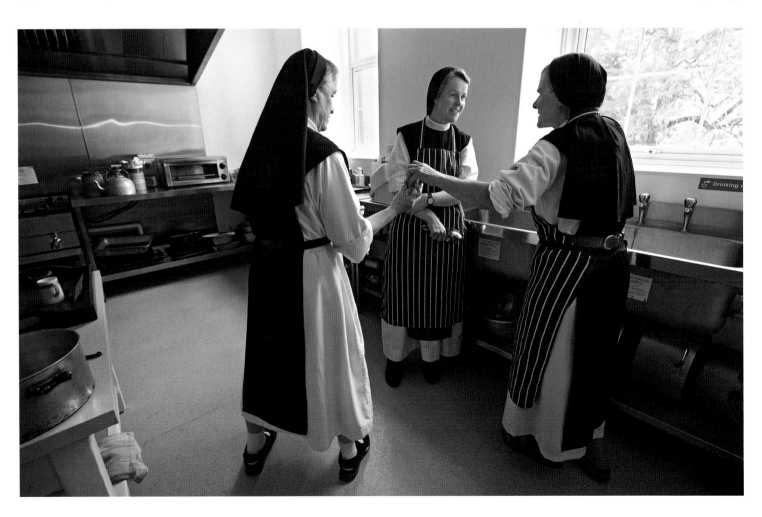

for a brisk walk in the woods. I make up for lost sleep in my lovely, cosy, new room, heated throughout from our own *Miscanthus* crop. It is the 5000-piece jigsaw set out on a table in the cloister that attract some sisters who enjoy mental stimulation.

After supper we have Vespers at 6 p.m. and Compline at 7.45 p.m. in the darkened church illuminated only by the lights of the little red lamps around the walls – reminding us that the light of Christ has come into our lives. After night prayer we go snoozzzzzz until Vigils the following morning. Our celebration continues right throughout the Octave. It is a time for relaxation, leisure and gratitude to the Lord for his goodness to us, and to our benefactors who helped to make our dream of rebuilding our monastery come true.

Sr Mairéad

SPRING

The daffodil symbolises new beginnings, rebirth and the coming of spring. It's bright, yellow colour and trumpet-shaped flower represent creativity and inspiration.

" Day by day the shadows shorten, higher climbs the noonday sun,
Wak'ning earth from winter slumbers, bringing life to seed and bud,
Clothing once again in splendour
trees and hedgerows, field and hill. "

(Text: Mount Saint Bernard Abbey,
Music: plainsong)

Below: Sr Josephine came to Glencairn Abbey in 1985, having spent twenty-two years as a Presentation Sister. A native of Dublin, she fondly remembers her childhood summers spent with family near Glencairn Abbey. 'I remember the grille separating the monastery in the church, I used to sit in the side chapel and hear them singing.'

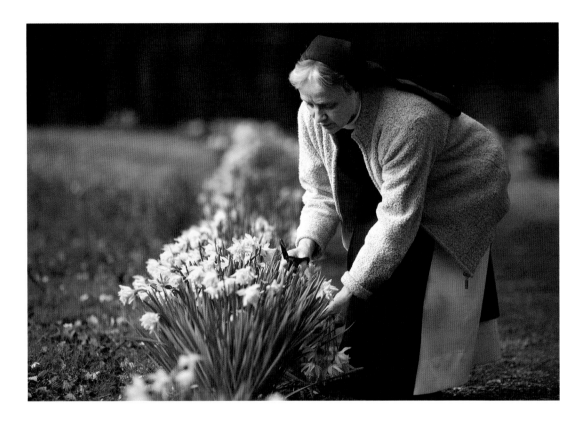

Opposite: Sr Lily is the farm manager of the two hundred acre farm at Glencairn Abbey. The farm specialises in dry stock and tillage, including wheat, barley, potato and fodder beat. Twenty-five acres are allocated to the growing of the energy crop *Miscanthus*. Sr Lily checks the *Miscanthus* before it is due to be harvested. Contractors are hired to harvest it in April each year. The monastery is no longer heated by oil – though oil remains as a backup – but by *Miscanthus*, which fuels their recently installed biomass boiler.

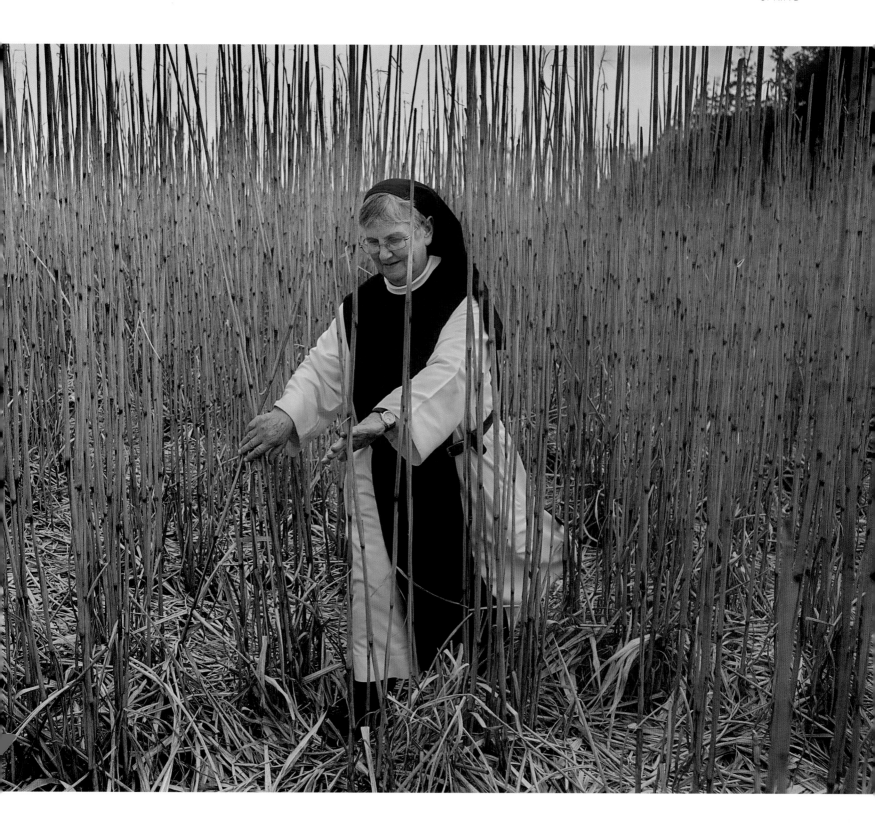

In 2014 Sr Lily oversaw the installation of an environmental and fuel-efficient Axe Biotech boiler now used to heat the abbey.

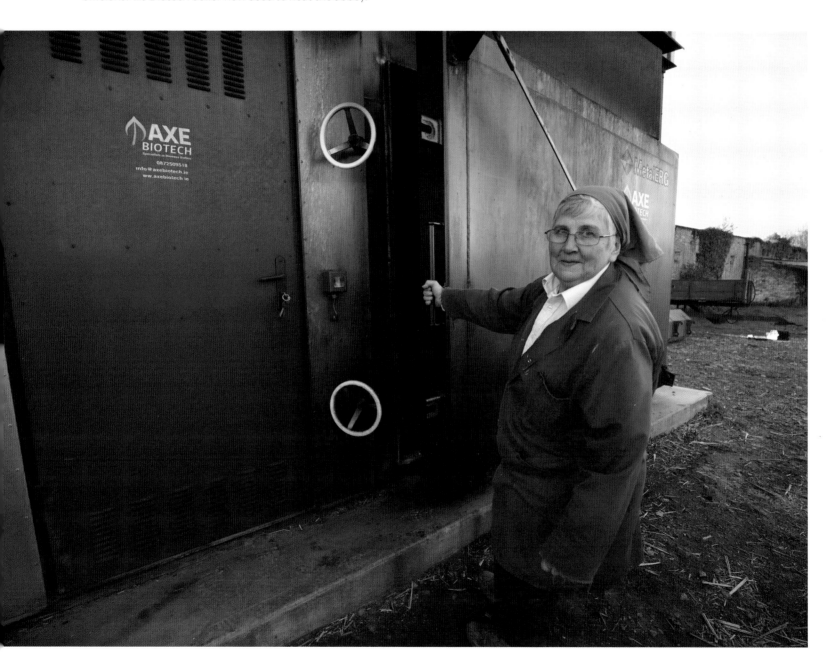

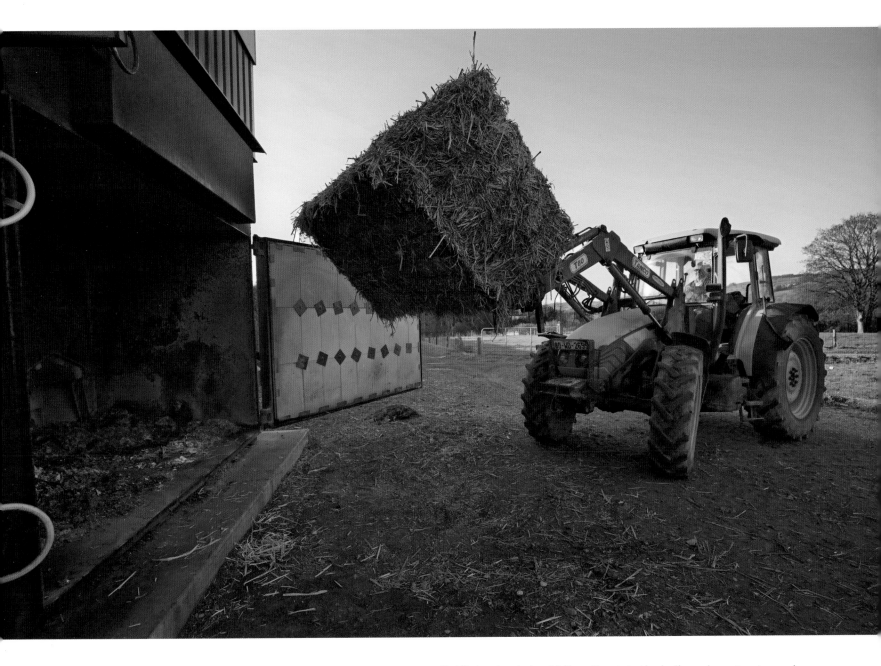

Sr Lily loads a bale of *Miscanthus* into the boiler using a tractor and loader. Three hundred and twenty bales will heat the house for the entire year, which includes heating the sisters' bedrooms, shower units, living quarters and kitchen. Even though it cost €120,000 to install the new system, it has already saved the monastery fifty per cent of its annual fuel costs.

VOCATION STORY

After my mother's death I was filled with dissatisfaction. I worked in a variety of jobs until I began a youth and community course at Jordanstown College, Belfast. I became disillusioned with the course towards its end and my personal tutor seeing this and advised me to

visit and talk to a friend of hers, a Dominican Sister, Sr Consuelo. We talked about the direction my life had taken up until that point. I felt on that day that I was in the presence of God. On my second visit Sr Consuelo advised me to apply for a job in Ballymurphy that had been advertised and to stay there until God had given me a sign. Pope John Paul II came to Galway in September of 1979. I was present to hear him speak so passionately to the youth of Ireland. His words, 'You will only find freedom in Christ', really caught my attention and I pondered and reflected over this during the following few months. One night in February of that year my bedroom was filled with light and a voice spoke to me, 'Lily, it is enclosed life I want of you'. I was frightened and tried to make sense of what had happened. I responded, 'Lord, I don't understand what it is you are asking of me so you must lead me to whatever it is you want for me'. With that a deep peace came over me and I realised that my life was going to change. I had given my consent for the Lord to take over my life and I placed my trust in Him to lead me.

In the following May I met Sr Agnes from Glencairn Abbey who invited me to visit Glencairn. The outcome of that visit was my decision to join the monastery there. It was the gentleness of Christ that I had experienced in Sr Agnes that touched me. It was the sign for which I had been waiting.

Sr Lily

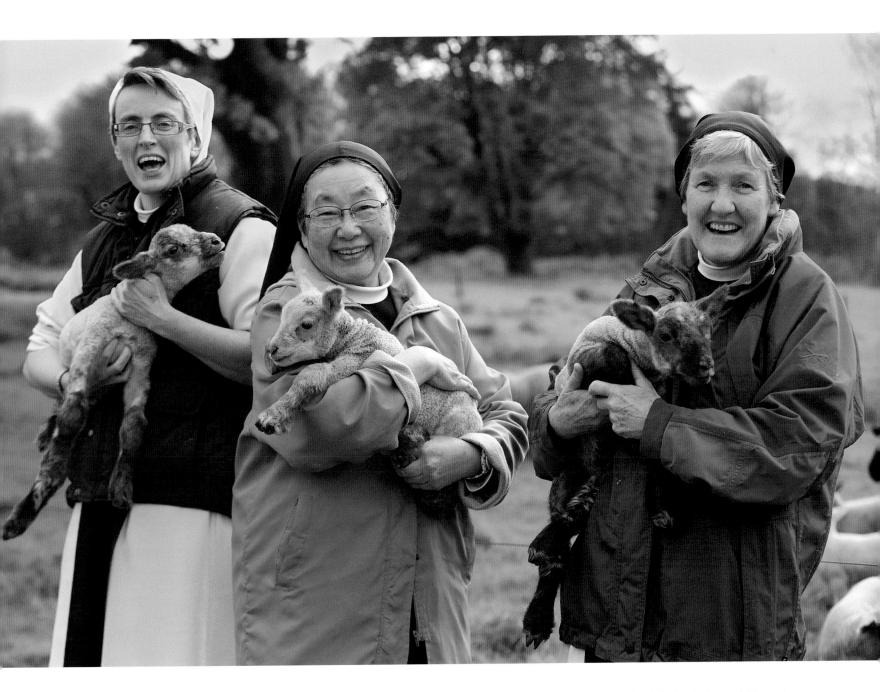

Sisters Liz, Clothilde and Mairéad with triplet lambs born at Glencairn Abbey. Springtime is a busy time at Glencairn as it is the lambing season – a relatively new venture for Glencairn. A mixture of Suffolk, Texel and Charollais ewes, a ram and hoggets are now stocked on the farm for breeding.

All in the April evening. A ewe wanders with her triplet lambs that were born at Glencairn Abbey.

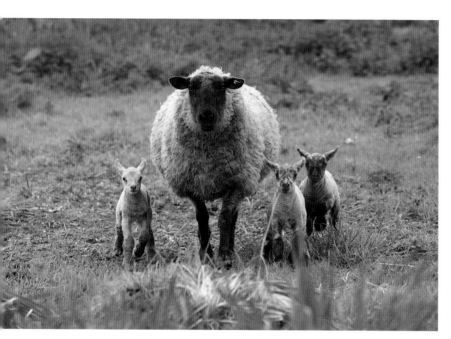

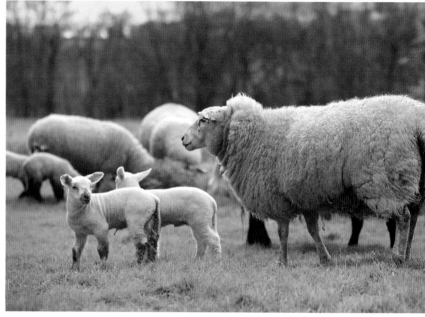

GRATITUDE

The earth seems to sleep through the cold and dark season of winter; then along comes the miracle of God in the spring. All of nature wakes up and takes on the task of filling the earth with grandeur and beauty. Here in Glencairn the lambing season ties in with the Lenten season with the birthing completed by Easter. It is fascinating to watch the little lambs running, skipping, jumping and doing their acrobatics in the fields. They seem to be expressing in their own way that, 'The Lord has truly risen, Alleluia, Alleluia'. (Lauds Hymn for Easter)

Sr Lily

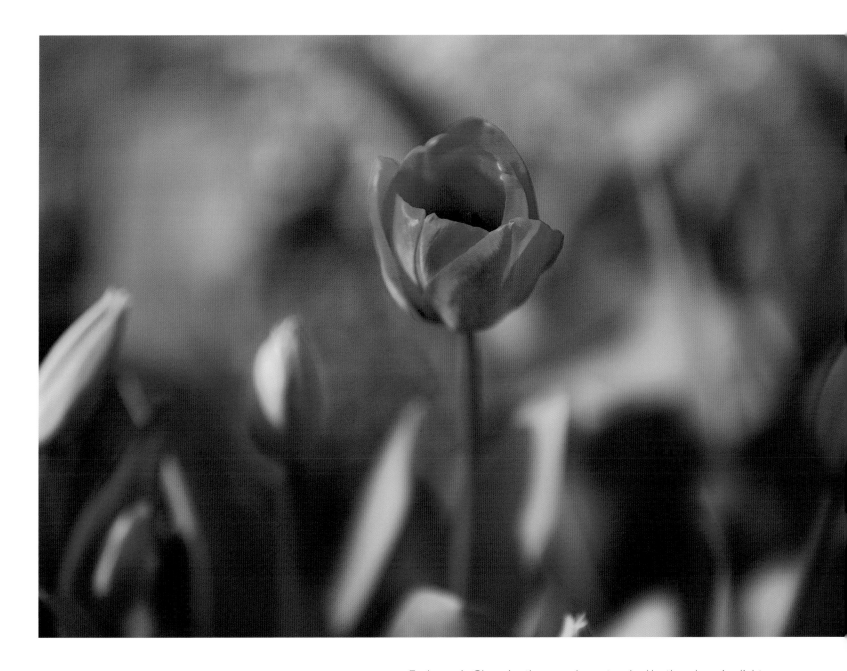

Each year in Glencairn the snowdrops, touched by the advancing light and warmth of spring, pierce the dark earth, heralding new life, growth and beauty. Here a tulip opens its heart. This growth continues until the roses in June, cascading over the garden wall, bring it to a climax. We see, and know, that the world is charged with the glory of God.

Sr Michele

By Ash Wednesday we have been prepared to welcome the ritual of repentance that inaugurates the Lenten season. The rubbing of ashes in the sign of the cross on the forehead of Christians echoes biblical practices, using ashes to express grief. The early monks prized this expression of genuine sorrow for sin. The monastic tradition shows that confessing the truth out of love is the basis of all spiritual growth.

Sr Sarah

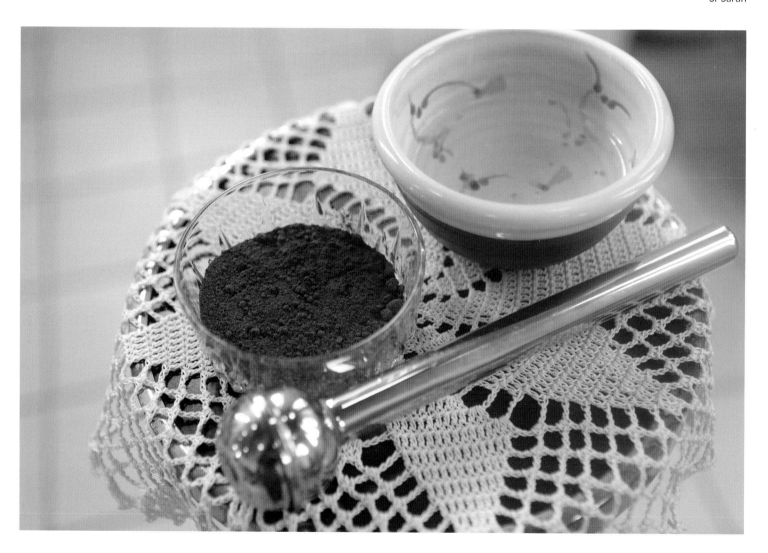

The ashes symbolise our origins. As the priest puts the ashes on the foreheads he says, 'Remember that you are dust and to dust you shall return'. (Genesis 3:19) In Lent we try to re-establish our relationship with God.

Sr Michelle

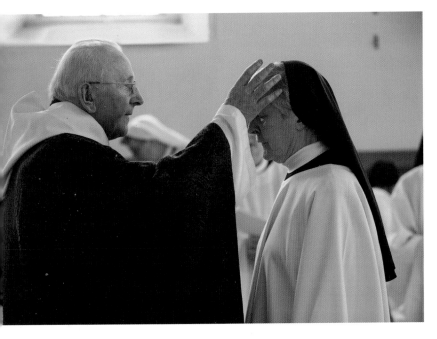

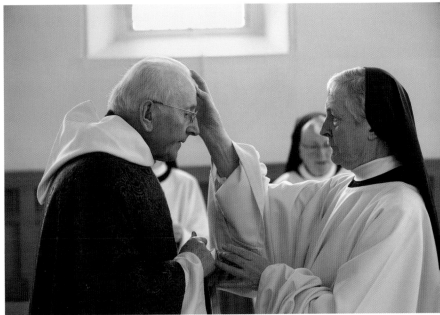

It is the beginning of Lent and in the monastic context reveals to us the true character of the nun. The *Rule of St Benedict* asks that we turn to prayer in our efforts to purify our hearts.

Sr Michelle

VOCATION STORY

One night in bed I suddenly experienced God's presence in a real, direct and personal way. I discovered God's love for me. He was beautiful beyond words and I recognised that He was love and that He loved me totally as I was. It was a limitless experience. I immediately knew who I was. I belonged to this God and nothing else mattered. I knew what I wanted to do. With great happiness I would follow this Lord, my newly found Beloved, in religious life.

Without much discernment I entered a missionary congregation and found myself in Nigeria. Of course the road had many twists and turns but He was ever at my side. I was overjoyed when I was offered a three-year course on formative spirituality in Duquesne University in America. In one sense it was a desert experience of silent reflection and serious study of the Church Fathers and Mothers, but I did recognise a gift for that work.

I did not plan my path to Glencairn; it happened providentially through a friend. There I discovered the truth of my own desires and this brought me great peace, courage and joy. I am immensely grateful to God for how He has led me. Love has lit the way and lightened the burden wherever He called me.

Sr Michele

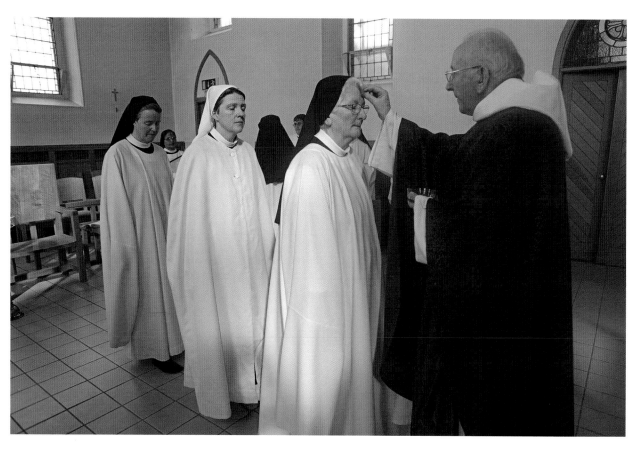

Above: Sisters Maria Thérèse, Angela and Sarah receive their ashes.

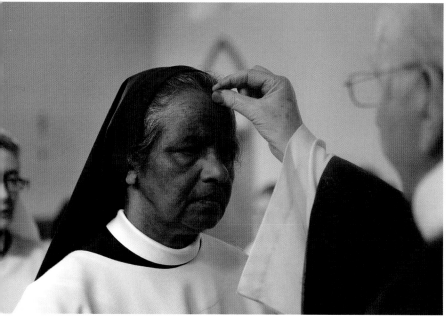

Left: Sr Scholastica, who is the sacristan at Glencairn Abbey, receives her ashes.

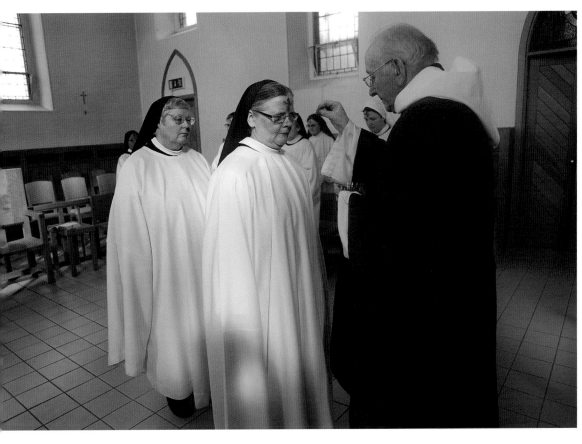

Left: Sisters Ann and Nuala receive their ashes. Fr Patrick wears the liturgical purple, the traditional colour of lent, to reflect the season's mood of penitence and simplicity.

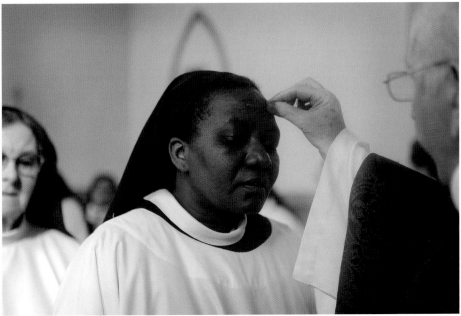

Right: Sr Anna receiving her ashes.

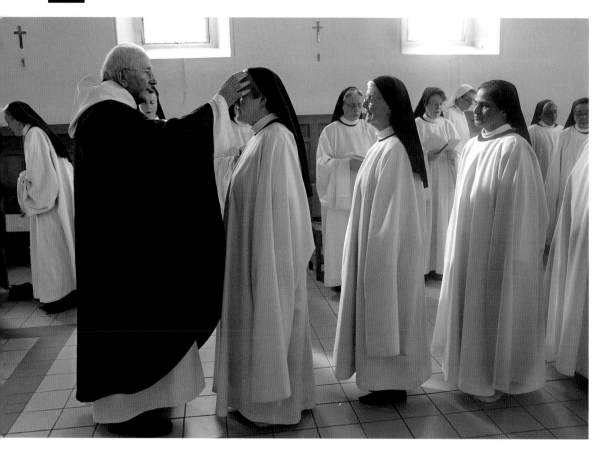

Sisters Mairéad, Gertrude and Robert Maria each receive their ashes.

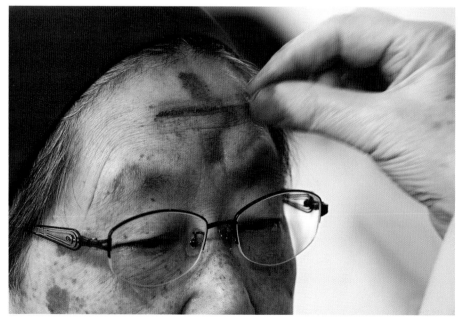

Sr Clothilde receiving her ashes.

On the first Sunday of Lent we read Chapter 49 of the *Rule of St Benedict* which says, 'At this season let us increase in some way the normal standard of our service, as for example, by special prayers, or by diminution in food or drink; and so let each one spontaneously in the joy of the Holy Spirit make some offering to God concerning the allowance granted him'. Following the Abbess' chapter talk the two chantresses hand out the Lenten books, each one covered in white paper by the librarian, and time is given each day, about forty minutes, for this Lenten reading. The discipline of sacred reading purifies our desires and enables us to discern God's action in our lives.

Mother Marie

MY TREASURY

One of the greatest riches of Glencairn is our beautiful environment, which provides a habitat for a truly wonderful range of wildlife. Over the ten years I have been here I feel incredibly blessed by many and varied sightings – oftentimes occurring at specific milestones of my monastic journey.

There was the leaping salmon reflecting the peach and mauve of an early sunrise; the kingfisher catching and devouring his supper; the otter and her cubs bounding along the frosty riverbank; the red squirrels chasing along the branches of a giant horse chestnut; the audacious stare of a magnificent fox, wending his unhurried way through the woods; the eye-catching humming bird moth feeding on a drowsy summer afternoon. All of these, and more, have been like a divine language without words, like a touch from God, engendering soul-deep and heartfelt joy and delight in the gift of life.

Sr Fiachra

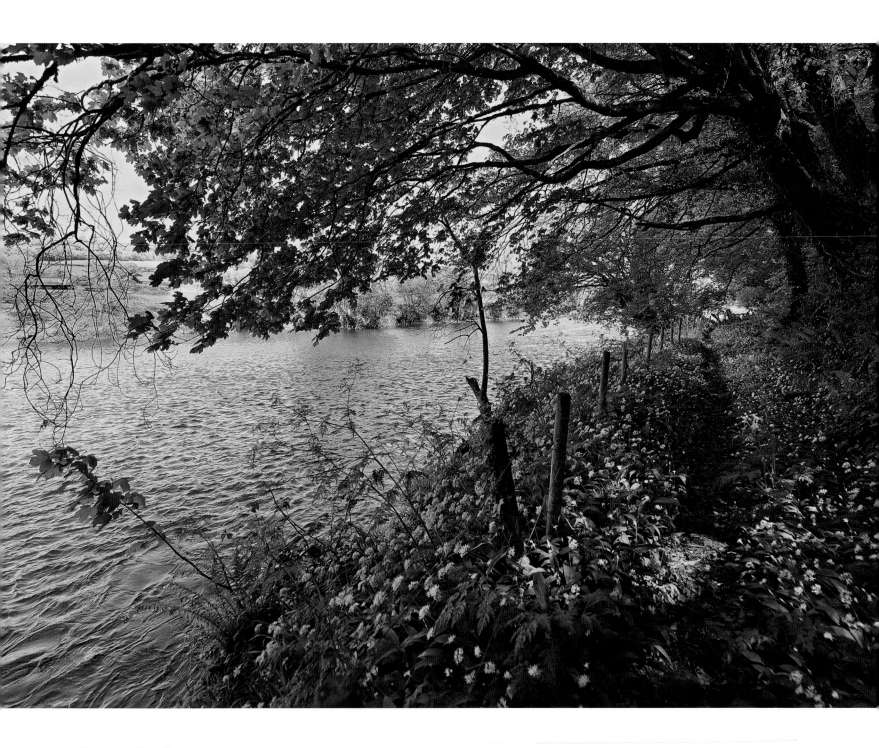

The season of Lent culminates with the most powerful and intense days of the Church's year, the sacred Paschal Triduum. These are three sacred days set apart; they are different, out of the ordinary. From the evening of Holy Thursday until Easter Sunday, together with the people of God, we celebrate the last days of Jesus' life on earth, his death on the cross and his resurrection from the dead.

At the evening Mass of the Lord's Supper on Holy Thursday, we recall the institution of the Eucharist by Jesus and his command to all his followers to love one another. This is symbolised by the Abbess washing the feet of the sisters and the guests. On Good Friday, a day of special prayer and fasting, we are invited to enter deeply into the Lord's suffering and to remember his death on Calvary. On Holy Saturday we watch and wait with Mary and the other faithful women by the tomb, a day of silent faith and hope. On Easter night, the night of the great Paschal Vigil, in the hours of darkness, the mighty act of God in raising Jesus from death and our sharing in his new life through our baptism are made present in the timeless rituals of prayer, readings, fire, water, song and acclamations of *Alleluia*, which resound through the Easter Sunday and through the following fifty days until Pentecost. It is celebrated unhurriedly, in a context of quietness and prayer, together with the many guests who come to share the liturgy of these days with us.

Sr Eleanor

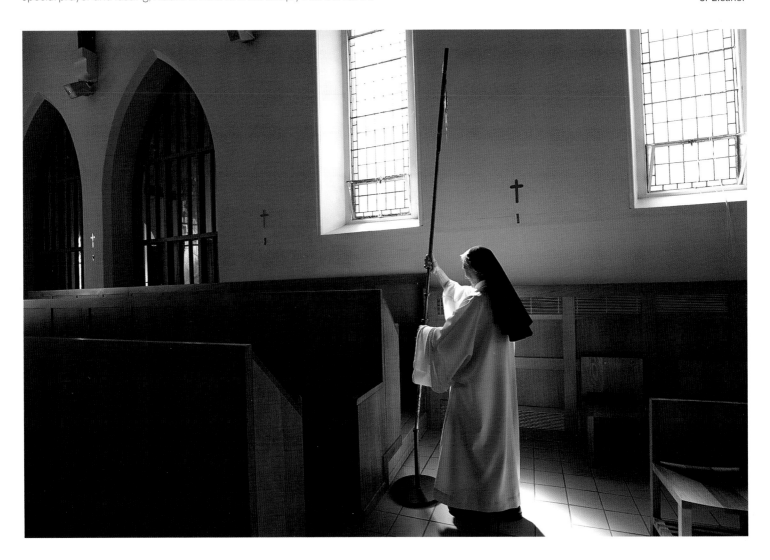

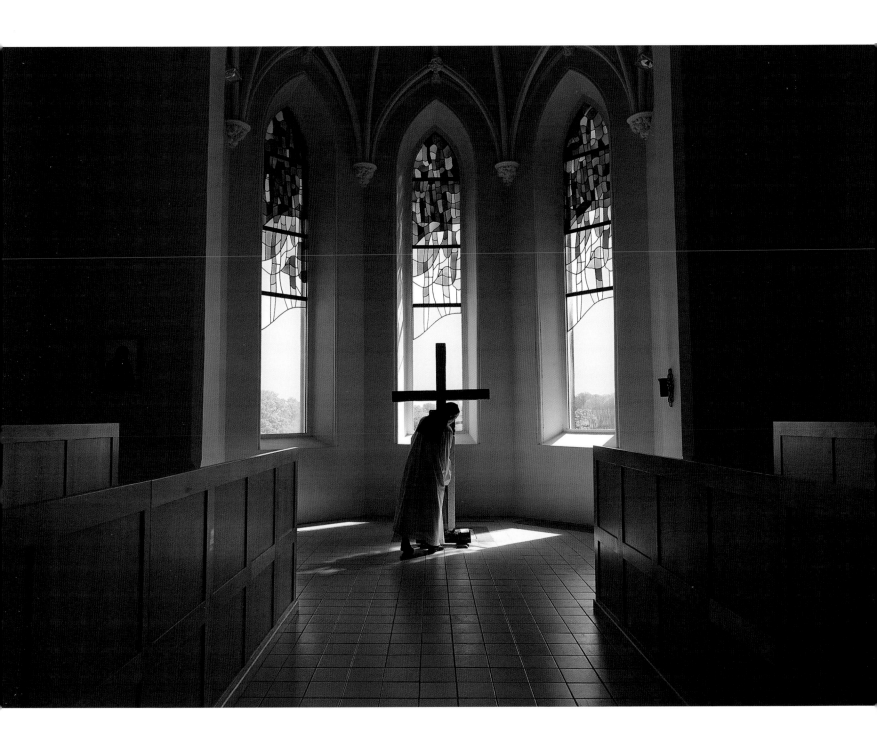

During the celebration of the Lord's Passion on Good Friday everyone must remove their shoes. For the procession each person, in turn, makes a deep bow before the cross and then kisses it. This is a sign of reverence, love for Jesus.

Sr Eleanor

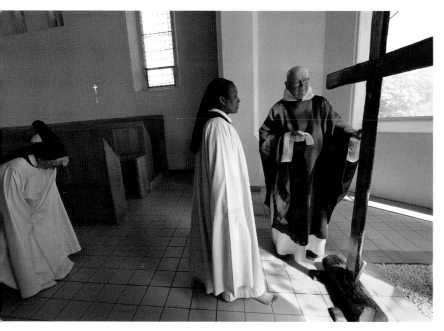

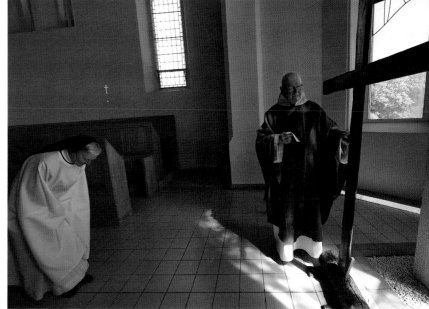

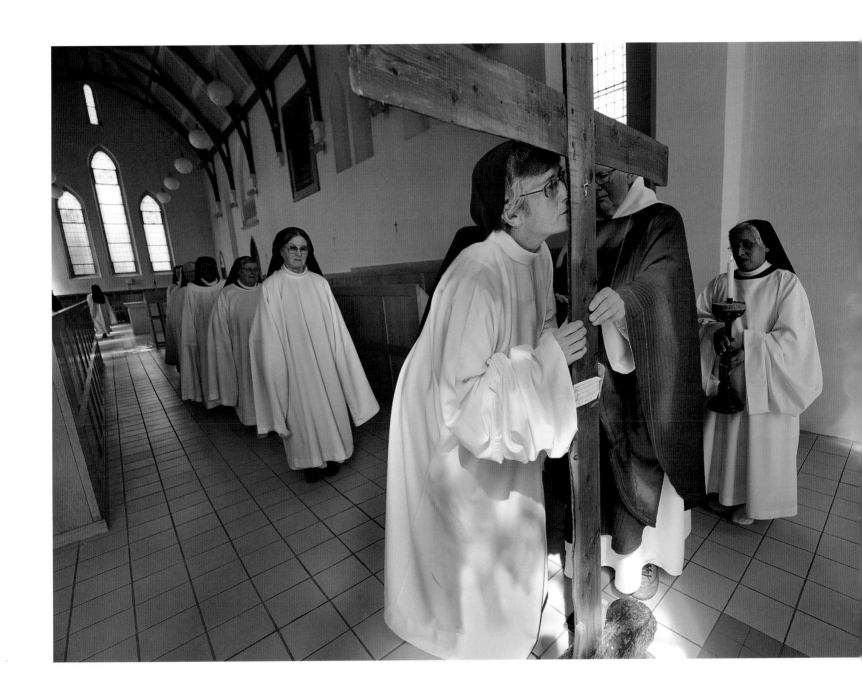

It is 2:50 a.m. on Easter Sunday and already the flames of the Paschal fire are casting their dancing light through the windows of our bedrooms in the monastery. After dressing and a quick coffee we go down in silence to the cloister where guests are making their way out to the fire under Sr Lily's watchful care. It is novel to have guests in the monastery enclosure. The ceremony is made all the more special by everyone's efforts to be here at this very early hour – some may have just gotten up while others may not have gone to bed at all. Gathering silently around the Paschal fire in the night air of the valley, a solemn moment descends before the priest begins the ceremony by blessing the fire and the Easter Vigil, the 'mother of Vigils' begins.

Sr Sarah

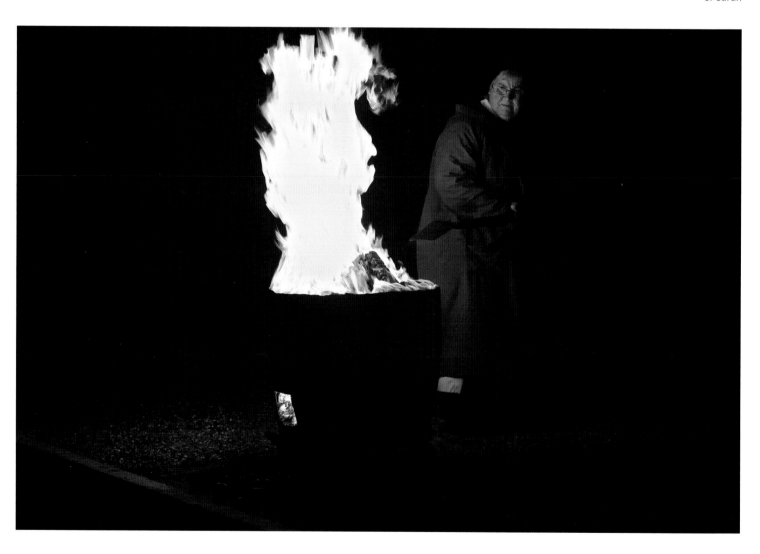

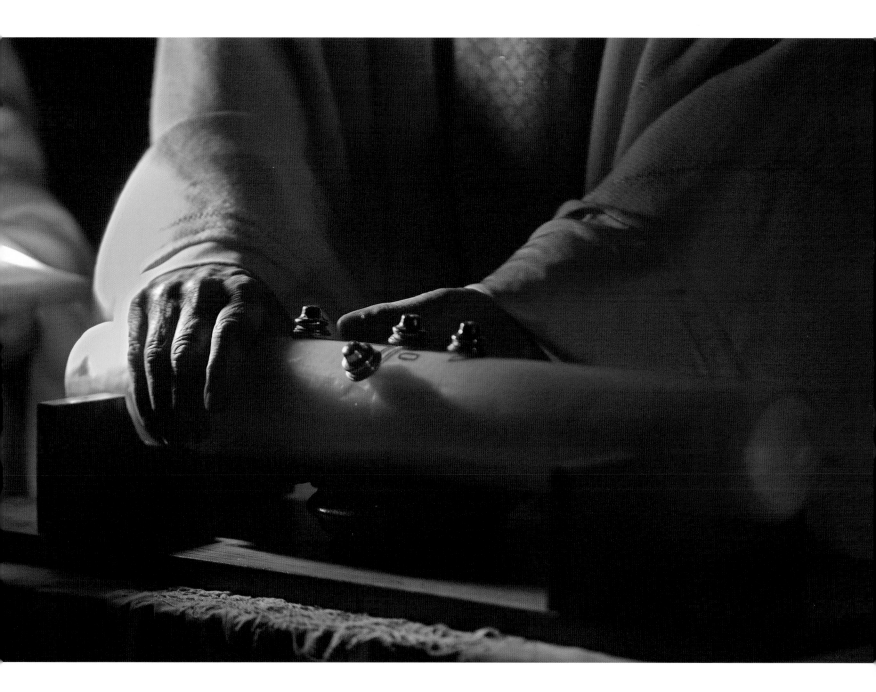

Dom Augustine lays his hands on the Paschal candle and cuts a cross into it. He then inserts five grains of incense into the candle in the form of a cross and says, 'By his holy and glorious wounds, May Christ the Lord guard us and protect us. Amen'.

Sr Sarah

Our Easter Vigil begins at 3 a.m. The Paschal candle is blessed and lit outside the North Hall door and the Paschal fire blazes on the path above the river under the stars. Our chaplain carries the Paschal candle through the North Hall door and along the dark cloister – it alone giving light. On reaching the steps leading to the church, he turns and sings the Lumen Christi. After our response, two sisters light tapers from the Paschal candle and go down along the cloister lighting each person's candle as they go. It is lovely to look down the cloister and see the faces appearing in the darkness as they are gradually lit from the held candle. When all the candles are lit we follow the Paschal candle into the dark church, gradually lighting it with our coming.

Sr Gertrude

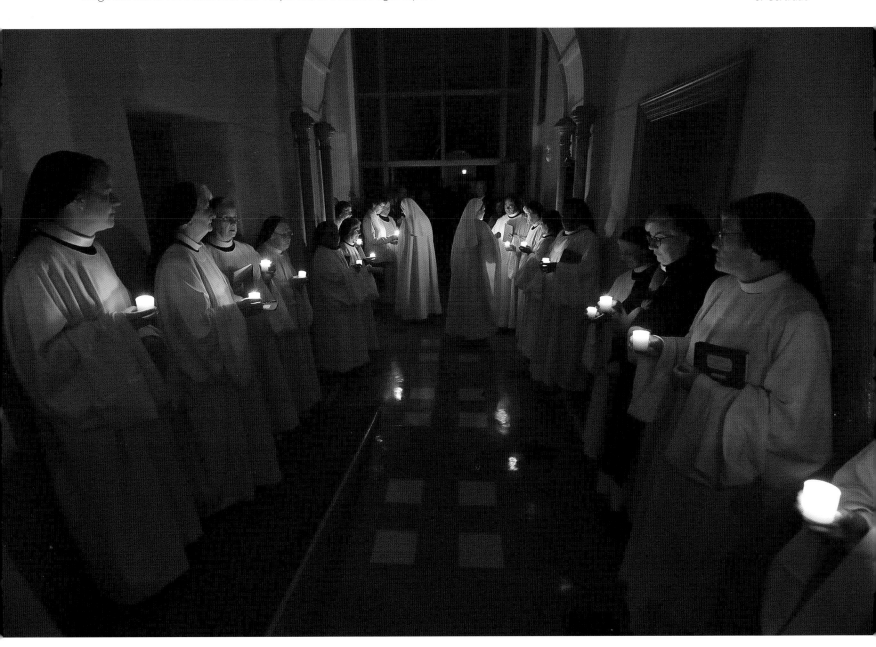

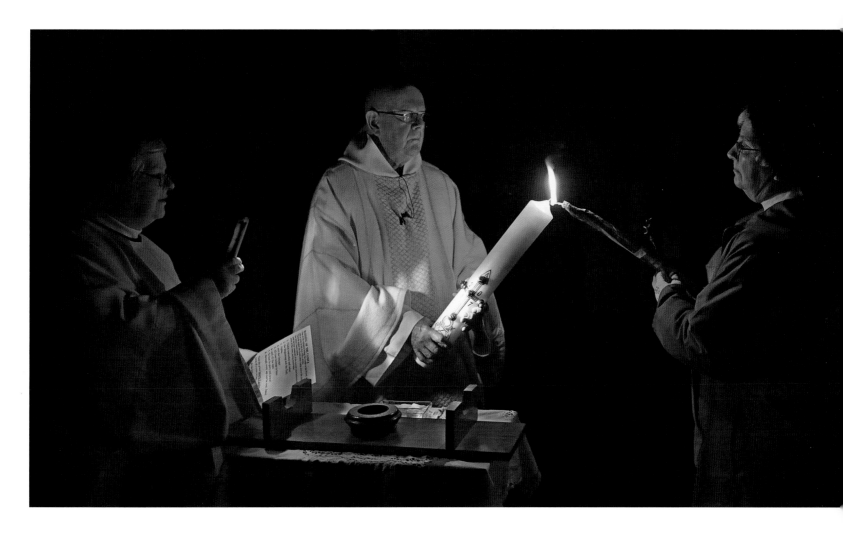

Sr Lily brings flame from the Paschal fire to light the Paschal candle held by Dom Augustine. Sr Nuala attends. Lighting the Paschal candle from the new fire, the priest says, 'May the light of Christ rising in glory dispel the darkness of our hearts and minds'. Once the incense has begun to burn in the thurible from the coals of the new fire, the procession to the church is ready to begin. The fire that brings light to our physical senses now brings light to our spiritual senses.

Sr Sarah

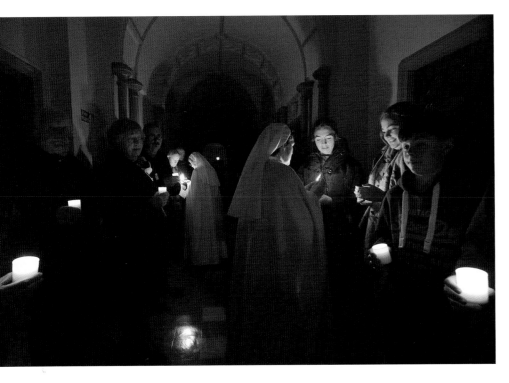

Above: Sr Angela lights guests' candles in the cloister.

Right: The many faces lit up in the abbey church at the Easter Vigil is beautifully captured and reminds us of our common identity.

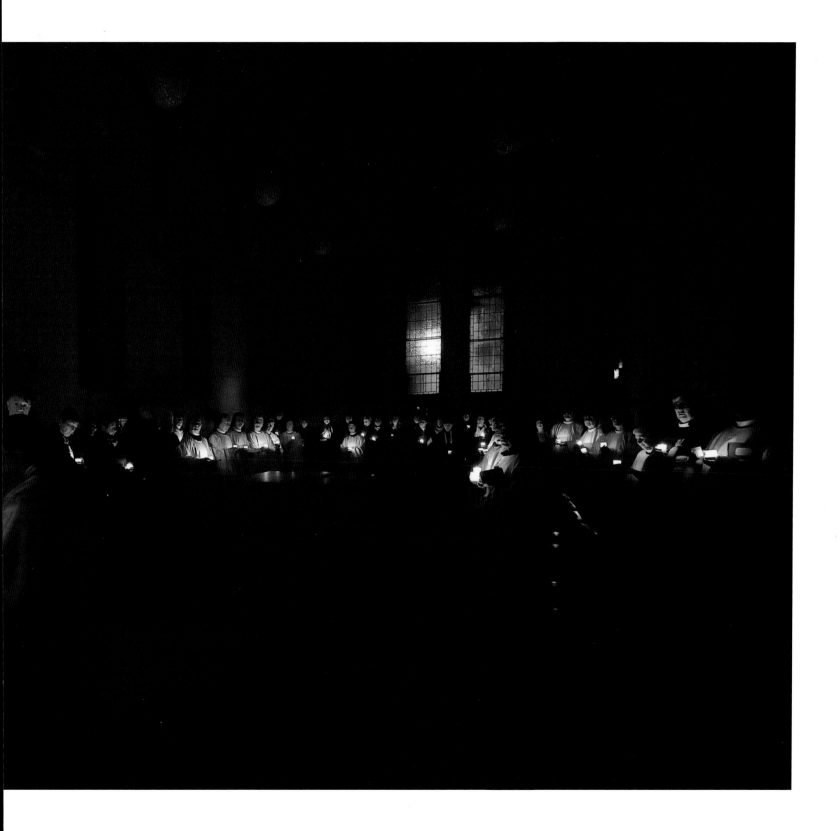

Left: Renowned organist and teacher Tim Fuohy of Fermoy, County Cork, accompanies the sisters and congregation at the Easter Vigil ceremonies every year.

Below: Angela Davis (left) Liz O'Hara and Richard O'Mahony, who sang psalms at the Easter Vigil at Glencairn Abbey.

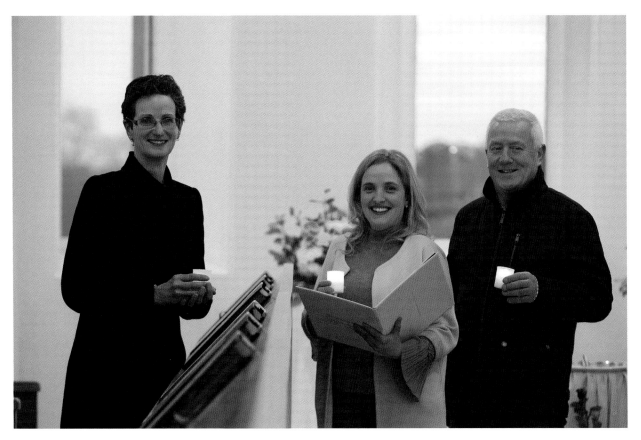

Right: Dom Augustine solemnly blesses the water in the baptismal font. The congregation and sisters are asked to renew their faith and in procession are blessed by Dom Augustine as psalms are sung.

Below: After the Easter Vigil, which usually finishes after sunrise, the sisters join with the congregation in the chapter room for morning tea and coffee and homemade cakes. Sr Mary catches up with regulars Patrick and David from Clonmel.

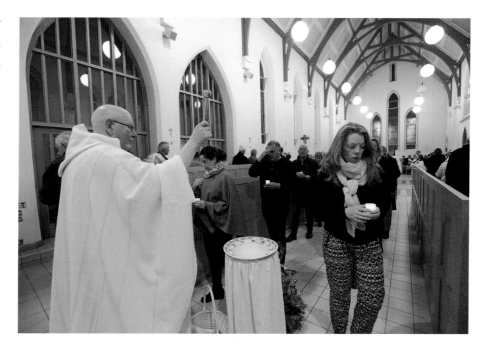

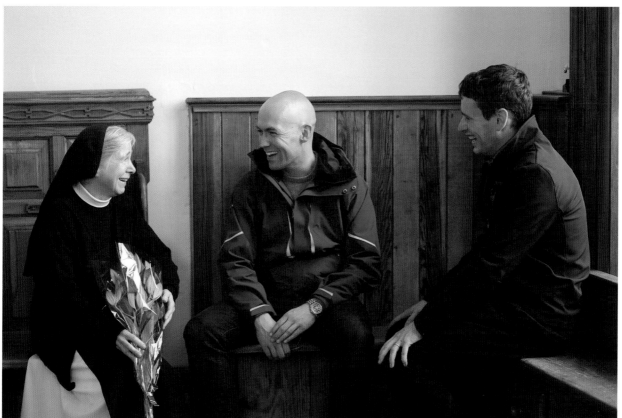

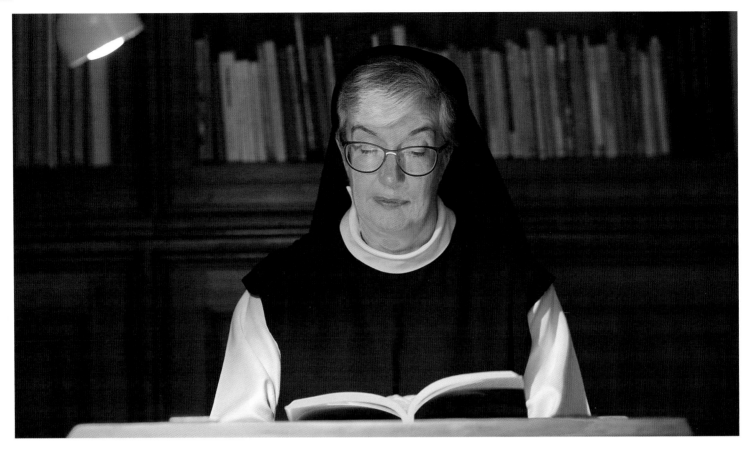

VOCATION STORY

Growing up in Lismore, I learned how St Carthage came to the Blackwater Valley in the seventh century and founded a monastery there. However, I had only the vaguest knowledge of the contemporary monastery just a few miles from Lismore, at Glencairn. My first real knowledge of contemporary monastic life came when I had left home and was working in Dublin. This knowledge came through a book, *The Cistercian Alternative* by André Louf, at a time when I was trying to figure out what God wanted me to do with my life. Working in a bank was a temporary phase, a job, not a career. A few months earlier, I had seen a vocations advertisement in a missionary magazine. It seemed to speak to me, 'Be a missionary!' After some initial shock and reluctance, I contacted a congregation of missionary sisters and spent a weekend with them. I gained great respect for the sisters and their work. Questions about the meaning of contemplative life became significant to me. I read *The Cistercian Alternative*. I suddenly had a new perspective. I began to see the value of a life dedicated to seeking God alone, with its daily round of work, singing psalms, listening to scripture and living in community. I understood how going apart to be with Christ can be a true response to the Gospel. Ironically, though the book spoke only of male Cistercians, one of the photos on the cover showed nuns and, being from Lismore, I knew it must be Glencairn. As the pieces fitted into place for me, I realised that was where I had to look next.

And so I came back to the Blackwater Valley and found God's path for me here. The unknown neighbours became my sisters in a monastic community that, now as in the time of St Carthage, is a school of love and a place of following Christ.

Sr Eleanor

Sr Michelle takes Rex, Glencairn's dog, on his daily run down to the River Blackwater.

summer

Summer brings its gracious blessings of fecundity and growth. The woods at Glencairn are transformed by a carpet of garlic and bluebells that appear in the month of May, which announce nature's return to the peak of its strength. Every tree, plant and shrub in field, wood and garden bloom with new life, freshness and vivid colour.

Summer corresponds with Ordinary Time in the Church's liturgical calendar. The colour of the priest's vestments are green, aptly symbolising the hope and growth of this season. The monastery is busy with much outdoor work to be done, and the sisters take time to simply enjoy nature. The community welcomes many summer guests and pilgrims, sharing with them the fruit of our life of prayer, work, silence and simplicity.

Below: Bob the pony arrived in Glencairn, finding a new home away from the noise and confinement of city life. He roams around the green fields keeping an eye out and a listening ear for his new friend Sr Clothilde. 'All animals wild and tame, O give praise to the Lord!' (Sunday Lauds Canticle)

Sr Lily

Opposite: At the cutting edge ... the Glencairn card department, Sisters Mairéad and Maria Thérèse, run the department, assisted by Sisters Kathleen, Kate, Clothilde, Robert Maria, Angela, Liz, Lily, Josephine, Denise and Mary Ryan, a much-appreciated volunteer. The newly refurbished card room (in the background) was renovated in 2015. In the nineteenth century, long before the sisters arrived, it was the old coach house. The production of cards first began in 1955.

Sisters Mairéad and Maria Thérèse

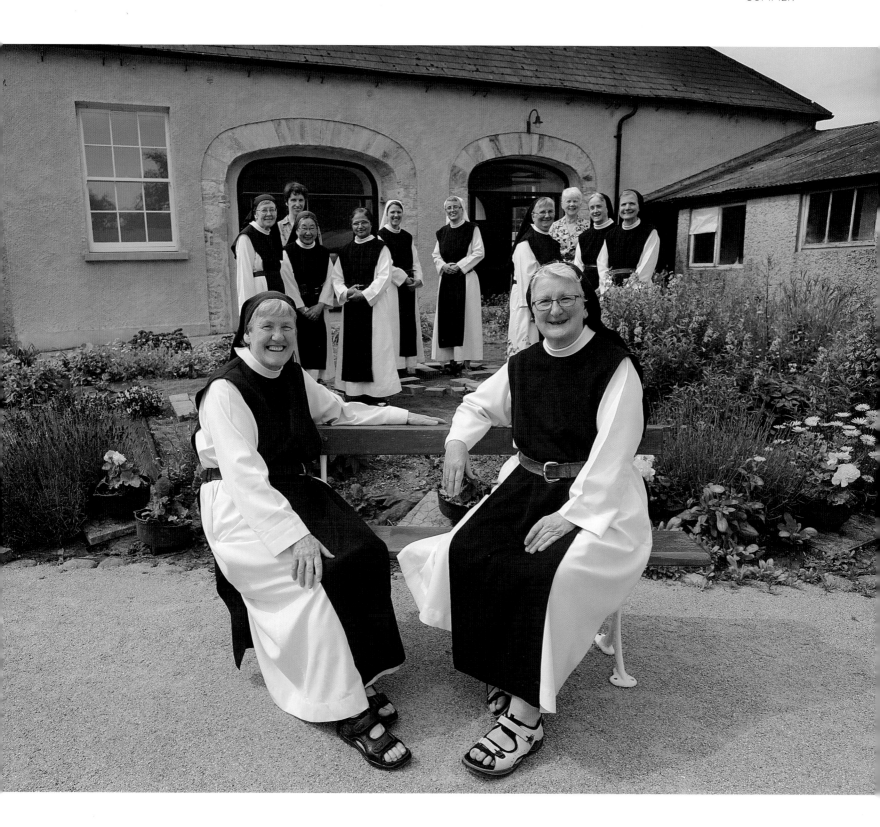

Above: Some of the work in the card room is done in silence, which gives an opportunity to practise mindfulness of God and personal prayer. The preparation of Christmas cards begins in August and we supply cards to a large customer base of individuals and wholesalers.

Sr Mairéad

Right: A variety of greeting cards for all occasions in Irish and in English are designed and printed by our sisters. Cards suitable for commemorating the deceased are created specifically to meet our customers' personal requirements.

Sr Mairéad

Left: Sr Josephine operates the folding machine. The various works within the card room include cutting, scoring and folding cards, as well as laminating and trimming memorial cards and prayer cards. We use a variety of machines that aid our work including the guillotine, creasing and folding machines and laminator.

Sisters Mairéad and Maria Thérèse

Below: Sisters Robert Maria and Mairéad pack and label packets of cards. Our work in the card department is an outlet for our creativity as well as being a source of income. A selection of our designs include printed reproduction flower cards as well as photo cards depicting nature scenes from our beautiful surroundings.

Sisters Mairéad and Maria Thérèse

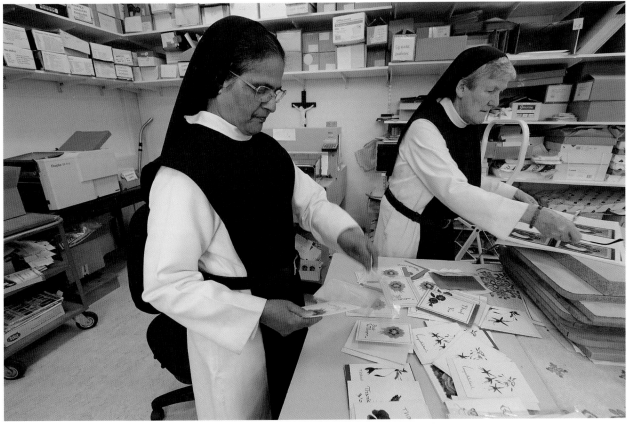

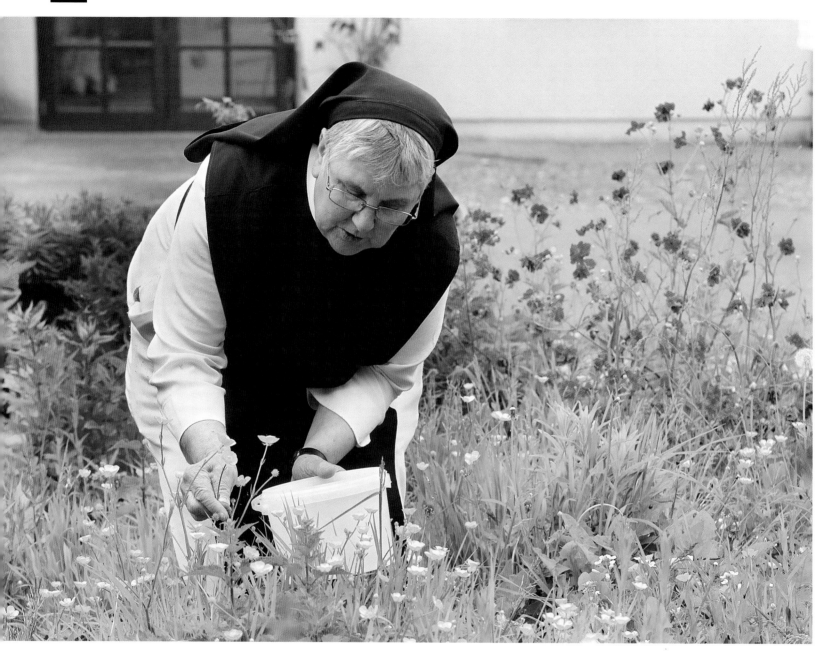

Sr Lily picking flowers for pressing. Seeds are set, flowers picked, dried and pressed before the flowers are affixed to the cards. A range of individually, handcrafted cards, produced from pressed flowers grown in the monastery gardens, are made to order.

Sisters Mairéad and Maria Thérèse

Left: A variety of pressed, dried flowers and leaves are tastefully arranged on each individual card according to the sentiment expressed by the card: Sympathy, Mass Bouquet, Thank you, Get well, Anniversary, Congratulations and Birthday.

Below: Praise him from the roof ... Sisters Michelle and Mairéad cleaning the solar panels on the newly renovated living quarters at the abbey. The new panels generate clean, green renewable energy from daylight – a free natural resource, thus saving on the monastery's substantial electricity outlays.

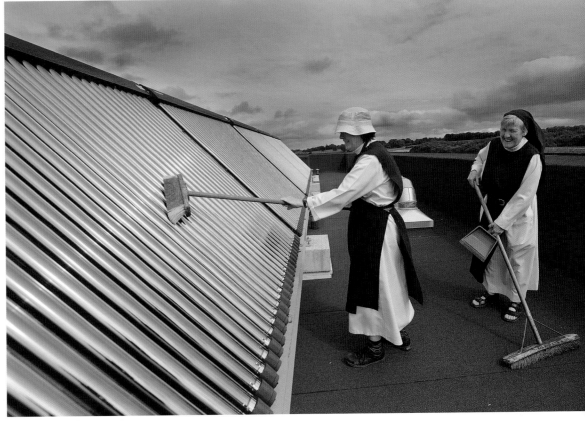

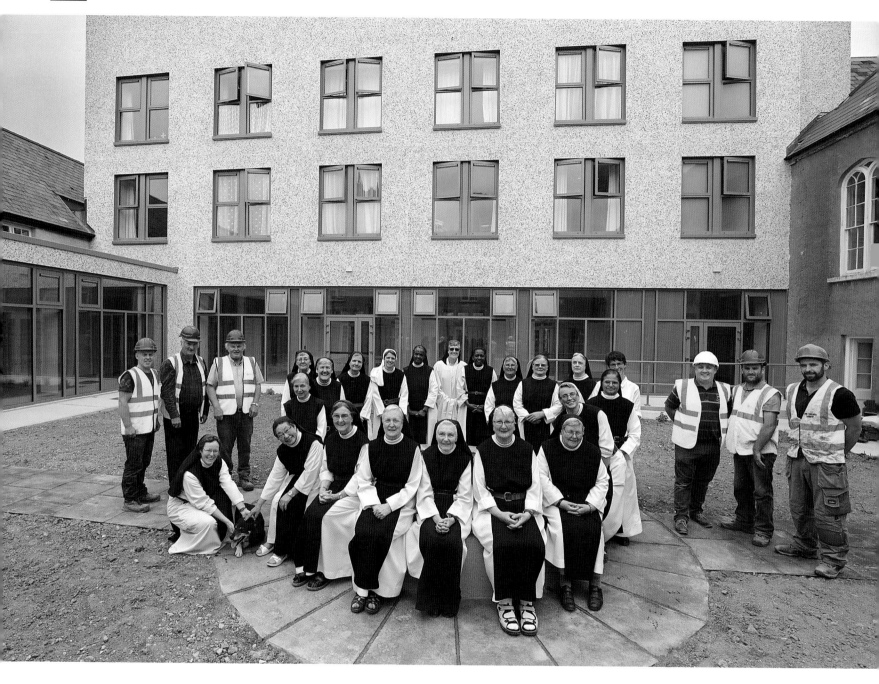

Another milestone at the monastery as phase three of the building project is completed. To honour the day the builders joined with the sisters in a small celebration. Included were, Denis Coffey, Eamon O'Gorman, Alan O'Gorman (O'Gorman Construction, County Tipperary), Vinnie Kennedy, Noel Lonergan, Albert Condon, Sisters Michelle (with Rex), Clothilde, Gertrude, Marie, Agnes, Maria Thérèse, Nuala, (second row) Mary, Mairéad, Kathleen, Denise, Liz, Scholastica, Fiachra, Anna, Lily, Ann, Josephine, Kate, Robert Maria and Liz.

A well-earned break after three years of construction and renovations at the abbey. The end of phase three is marked in true Glencairn style.

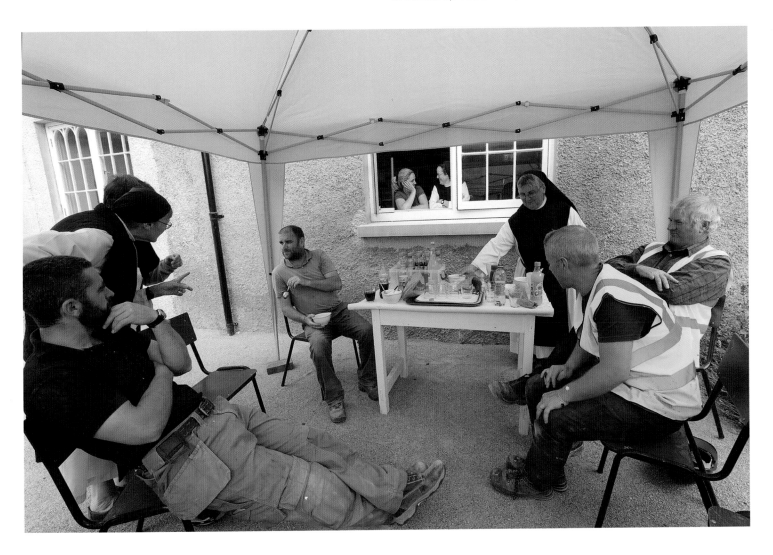

Feeding time on the eaves … A house martin feeding her chicks in summertime at the abbey, a time when insects are abundant. The nest is made of pellets of mud mixed with grass and lined with feathers. They are summer migrants and spend their winters in Africa. This year Sr Maria Thérèse sighted a number of swifts in the area. So a special swift nesting box was installed on the eave of the cloister garth complete with a recording of the swifts sound to attract the birds. Within three days, to her delight, she had spotted two swifts entering the nesting box. The swift is an amazing and mysterious bird. They eat, drink, sleep and mate while flying. They are extremely fast, approaching their nests at more than forty miles per hour and stopping without ever slowing down. They do not normally land on the ground because it is difficult for them to take off. They catch bits of feathers, leaves, petals and pieces of paper from the air to make a cosy nest in which to lay their eggs. After the young leave the nest they keep flying for two to three years until they are ready to find a partner and they usually stay with that same partner for the whole of their lives, at least twenty-one years.

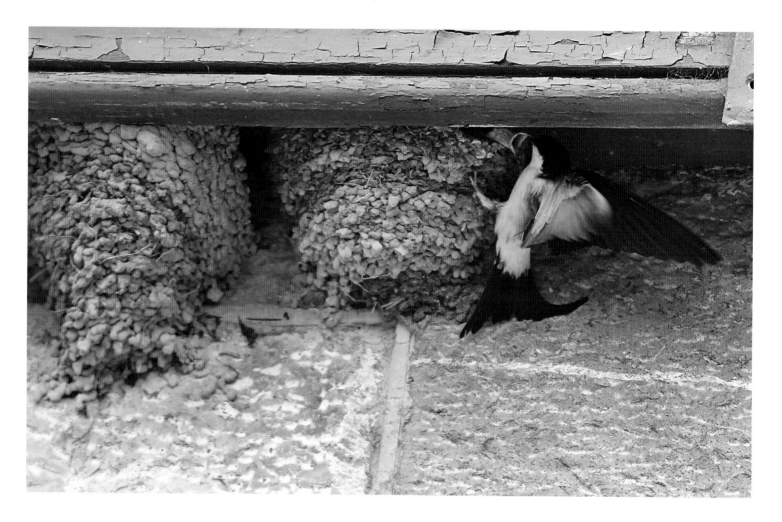

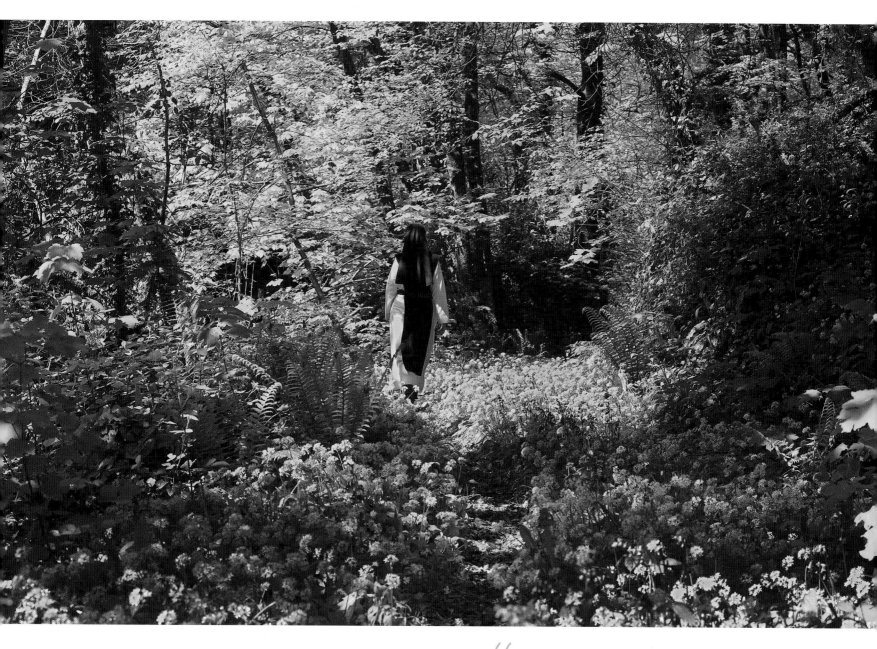

As monastics we possess nothing for ourselves, we see the natural resources of our monastery as gifts from God to be received with thankfulness and to be returned at the end of our lives, hopefully viable for future generations.

The psalms and canticles that we sing everyday are full of creation themes, wonder, and gratitude.

" Plants of the earth, O bless the Lord,
Fountains and springs, O bless the Lord,
Every bird in the sky, O bless the Lord,
To him be highest glory and praise for ever. "
(Canticle of Daniel 3:57–88)

Sr Mairéad

VOCATION STORY

On leaving school aged eighteen, I returned home to join the staff in my father's business in Windgap, County Kilkenny. My aim was to eventually get married and have a family, but at eighteen there was time to enjoy life. One place I did just that was in the dance hall that my father owned. I really loved dancing. I would dance all night until the last dance was announced. Another big attraction was the camogie team. In Windgap there was a very good team and each evening we'd all go to the camogie field to practise and that was wonderful. Without televisions in the homes then, the people would be glad to pass the evening in the camogie field.

By this time I was beginning to hear a gentle voice suggesting religious life to me, and though I first turned a deaf ear the voice persisted.

It was my uncle Fr Edward O'Shea that first brought me to visit Glencairn. When we arrived at the monastery there was a counter there and a wooden grille on top through which the porteress, Sr Brendan, had smiled at me. I didn't expect to see any smiles, so that smile was a great help. The Abbess questioned me as to why I was thinking of entering Glencairn and said that I could come and try once I was over twenty-one.

On Sunday 13 May 1951, the Feast of Our Lady of Fatima, a lovely sunny morning, my father, mother, sister, a friend and myself drove to Glencairn. The day one leaves home to enter religious life is not an easy day for anybody. To my great surprise on entering the cloister I met the nuns as they went about their work and though nobody spoke, everybody I met gave me a beautiful smile and a nod of recognition. My first impression of Glencairn was that it was a very welcoming and happy community, and that impression has never changed, not in the past sixty-six years of my life in Glencairn. I am most grateful to the Good God for the many graces and blessings received and to Mary, His Blessed Mother, and my mother, on whose Feast Day I came to Glencairn.

Sr Agnes

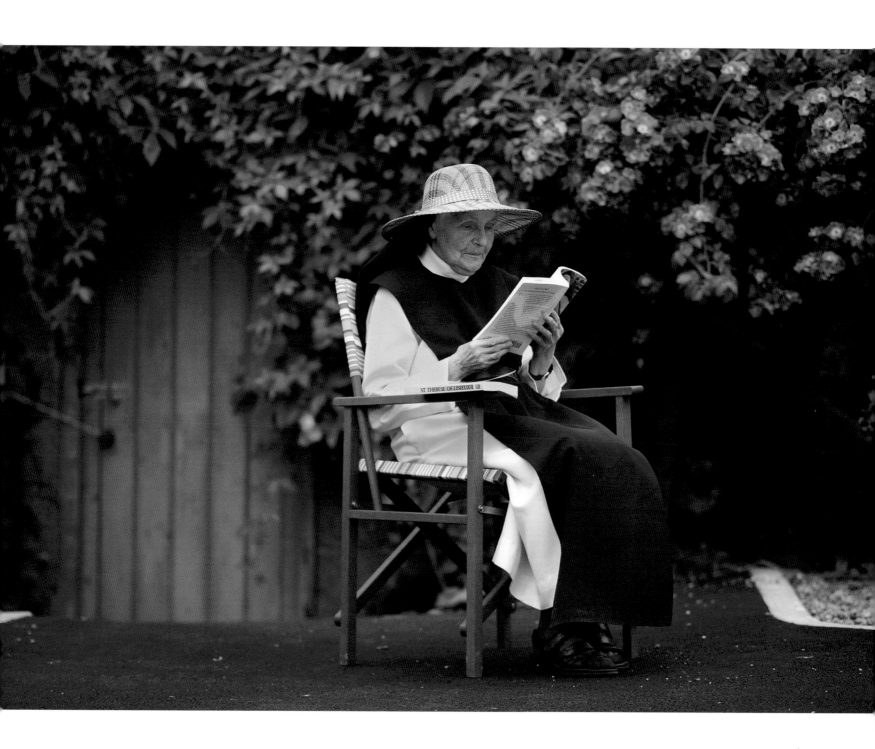

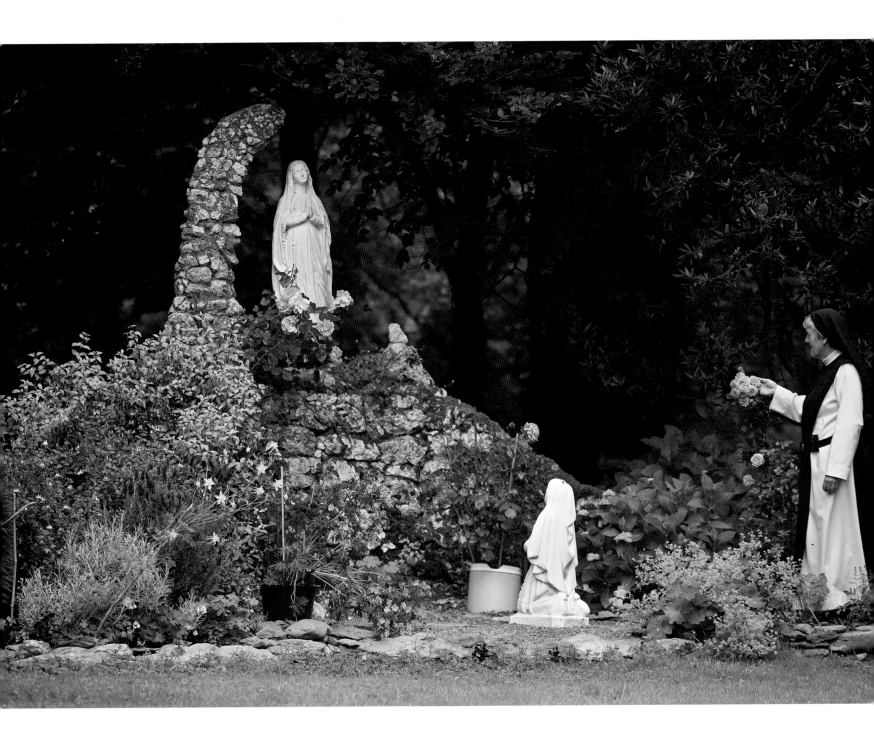

VOCATION STORY

One of seven children, I grew up in a happy rural Catholic environment in Spiddal, Connemara, where there was an ancient and beautiful tradition of invoking, by ourselves or others, God's blessings on our daily chores, and a prayer for every occasion. I experienced the love and support of my parents throughout my childhood, and my earliest memory is listening to the consoling rhythm of the recitation of the family rosary as I lay in my cot at night.

I did not experience God's call until late into my forties. I was both surprised and alarmed to experience an attraction for religious life at this mature stage of my life. I had a comfortable lifestyle; I worked in the Central Bank in Dublin and enjoyed a busy social life with a wide circle of family and friends. My long-term plan was to take early retirement and travel before settling down to a peaceful life in my native Connemara. But God had another plan for me!

I became more restless in this busy worldly existence as I advanced in years and I yearned for a more meaningful and simple way of life centred on God. For the first time I started to respond to this irresistible call deep within me, which led me to Glencairn. A radical change occurred in my life, as I renounced all my personal possessions and gave myself unsparingly to God.

I thank God each day for the gift of my vocation and for leading me to this peaceful and life-giving place. Throughout my life I have experienced the love and the care and the goodness of God and I want to repay this goodness by becoming a witness and a channel of His grace.

Sr Mairéad

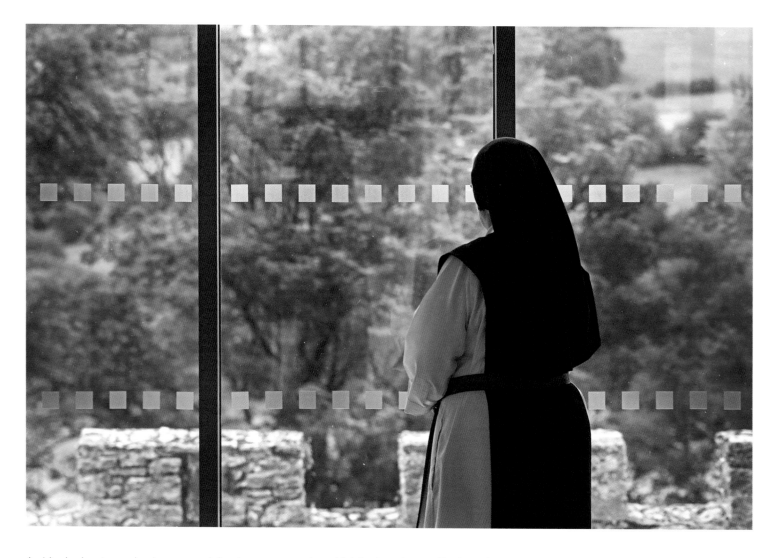

As I looked out one day I saw a rook land on a young elm which had survived for about eight years but now alas is dead with its branches brittle. The rook caught a piece of one of the little branches, bent it and snapped it off and then flew with it in its beak to add it to its nest. The rooks gather in huge numbers around the monastery at evening time. They always remind me of a little poem by Richard Monckton Milnes that my Dad used to recite, 'A fair little girl sat under a tree ... Such a number of rooks came over her head, Crying, "Caw! Caw!" on their way to bed; She said, as she watched their curious flight, "Little black things, good night! good night"!' It is a very calming poem and there is a sense that all is right with the world, a sense of order, a sense of calm and quiet at the end of the day.

Sr Maria Thérèse

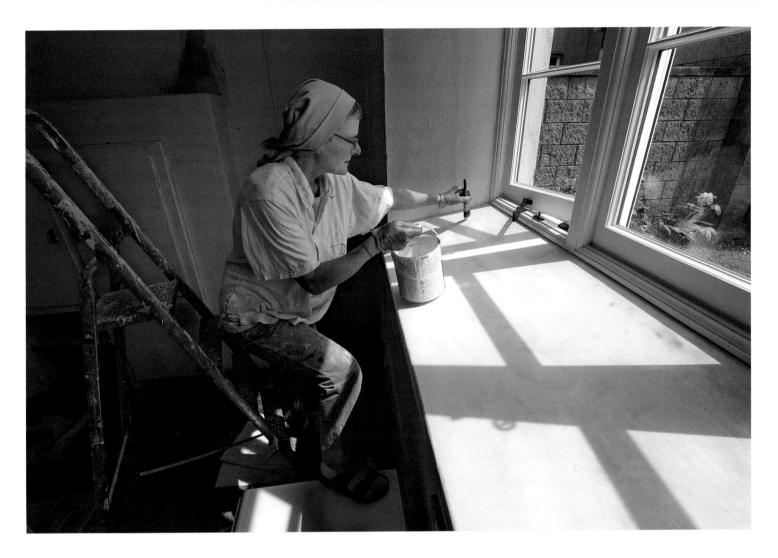

The work ethos of our monastery is fourfold – ascetical, earning our living, a moderate, balanced way of life and sharing with those in need. All activity is embraced in a spiritual perspective, motivated by Christ's attitudes, values and example. Being responsible and generous grounds us in humility of the heart and with a deep patience. Our service gives concrete expression to our gratitude and praise of God. Singing in choir unfolds and echoes throughout the day in the work of our hands.

Sr Denise

A delightful crop of Glencairn's summer bluebells.

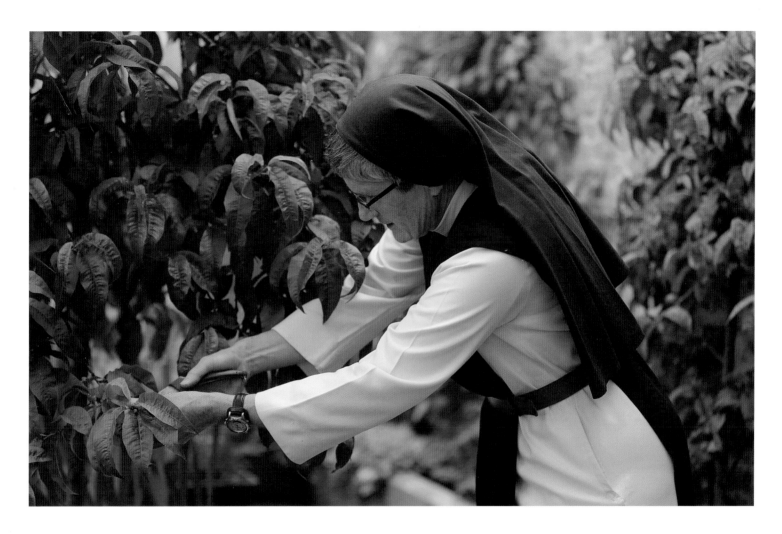

As spring gives way to summer and days get longer and warmer, our showery weather gives rise to galloping growth and swelling fruit. Ensuring quality of yield and sweetness of flavour are the things that preoccupy us in both orchard and garden at this time, as we focus on pruning over-exuberant growth to expose developing fruitlets to as much sun as possible. Such pruning also helps to establish and maintain the framework of young and semi-mature plants so they will effortlessly support abundant crops in subsequent years. Each year, while undertaking this work we are presented with a fabulous opportunity to reconnect with and meditate upon that well-known and well-loved fifteenth chapter of St John's Gospel. 'My Father is glorified by this, that you bear much fruit and become my disciples.' (John 15:8)

Sr Fiachra

VOCATION STORY

I entered St Mary's Abbey, Glencairn when I was twenty-eight years old. I had studied English Literature at University College Dublin and after that had worked in the media. My knowledge of monastic life had been awakened when I was a child. My father had gone to school in Mount St Joseph Abbey in Roscrea and had maintained his link of friendship with the monks who lived there. I had always been touched by their presence and their monastic way of life. Later, in my twenties on my travels, I came across a Cistercian monk of this community. His life given to God seemed to make sense to me at a deep level within and I felt the call.

When I returned to Ireland, I began my search in earnest, re-visiting the abbey in Roscrea. On one such weekend there, I met a Cistercian nun from Glencairn, and there and then I resolved to visit her community and find out what monastic life was like for women.

The state of tension and fear in which I arrived at the monastery for that first visit was soon relieved by the welcome sight of wide open fields and crops glinting in the evening sun, the warm hug of the guest mistress sister at the door and the beautiful singing of the nuns at Compline in the abbey church. It was, however, the silence that spoke to me most of God's loving presence and call. I began to consider for the first time my own Cistercian vocation. It took me two more years to make up my mind to apply to enter Glencairn and with that decision came at once both a sense of coming home and a setting forth.

Monastic life, I have come to learn, is a journey through my humanity to that profound encounter with God's mercy in my weakness and the joy of discovering Christ at an intimate level in my life, in the life of the community to whom I am given and in the life of the world for whom I am interceding in prayer, worship and self-gift. My rootedness then as a Cistercian has been ultimately sustained by my rootedness in Christ, the one attachment through which I will paradoxically find the freedom to embrace all.

Sr Sarah

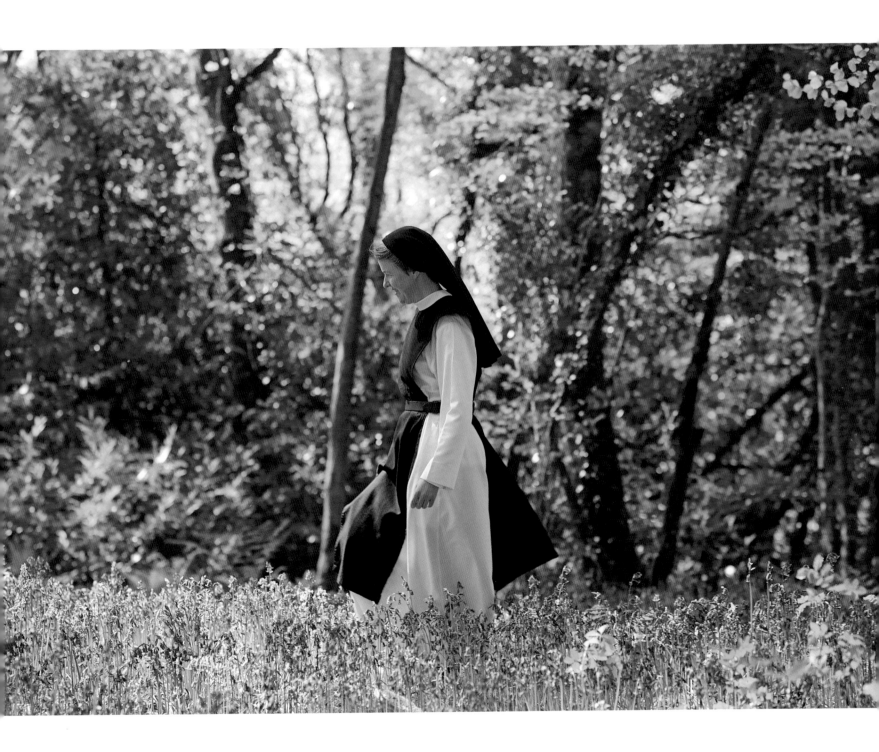

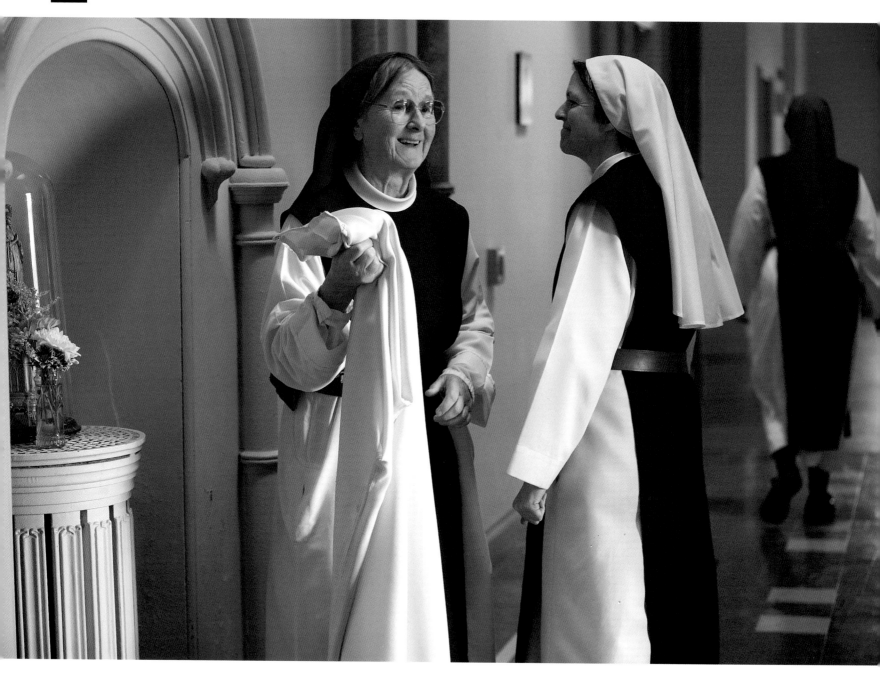

'That you love one another, just as I have loved you.' (John 15:12) Sisters Gertrude and Angela having a few gentle words on the corridor, after the daily Office of None.

A little birdie told me ... Sr Sarah having a chat with Caitlin Barry, who was on one of her many visits to the abbey. Her granny Nellie O'Donovan works in the Eucharist Bread department.

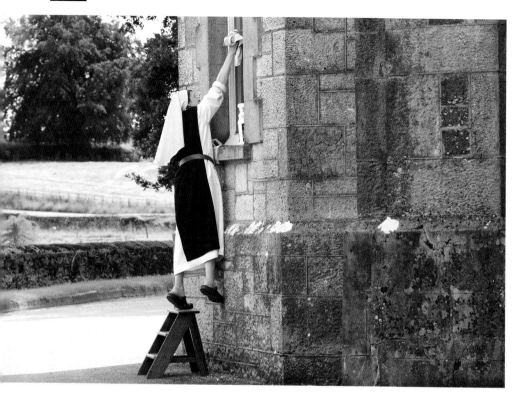

At the centre of all monastic life is work and prayer. Prayer is a moment of intimacy with God, in church or in solitude. Work is also their prayer, whether it is washing the windows from the deposits left after the nesting house martins, working on the farm, in the card department, making Eucharist bread or maintaining the monastery's website.

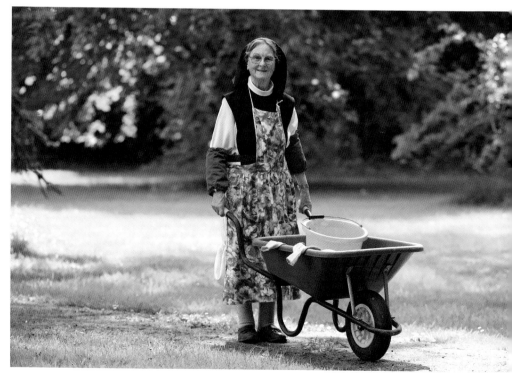

Sr Gertrude tending to the garden at Glencairn.

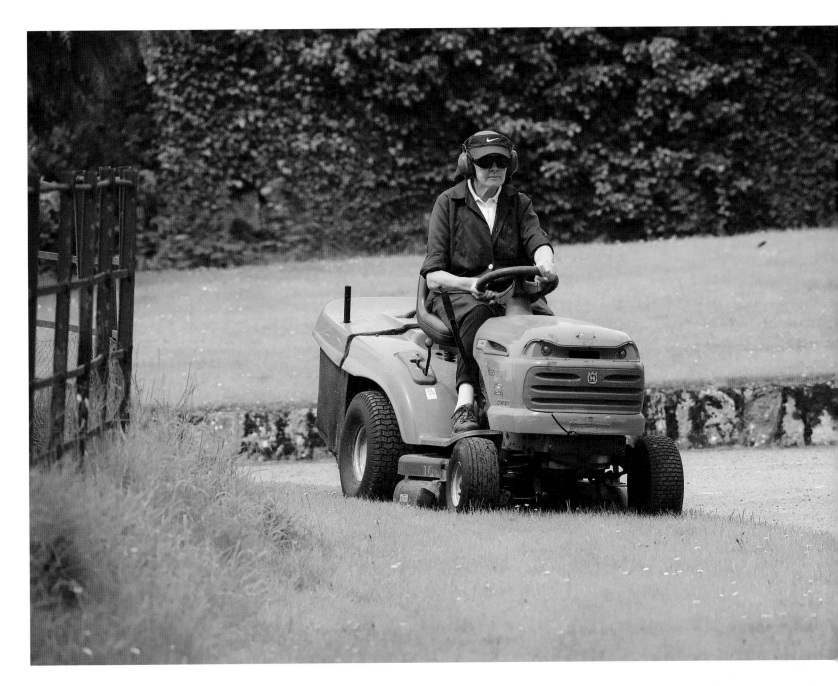

Sr Kathleen really enjoys cutting the lawn and grass surrounding the abbey grounds at Glencairn, she can get up to great speeds on her sit-on lawn mower.

Below: 'You are my place of quiet retreat, I wait for your word to renew me.' (Psalm 119) Sr Angela tends to the plants at the abbey.

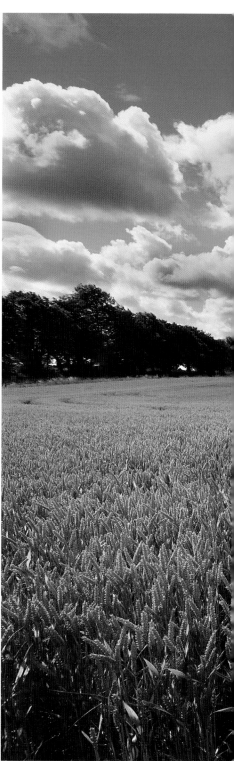

Opposite: 'As long as the earth endures, seedtime and harvest, cold and heat, summer and winter, day and night will never cease.' (Genesis 8:22) A crop of wheat is almost ready to be harvested.

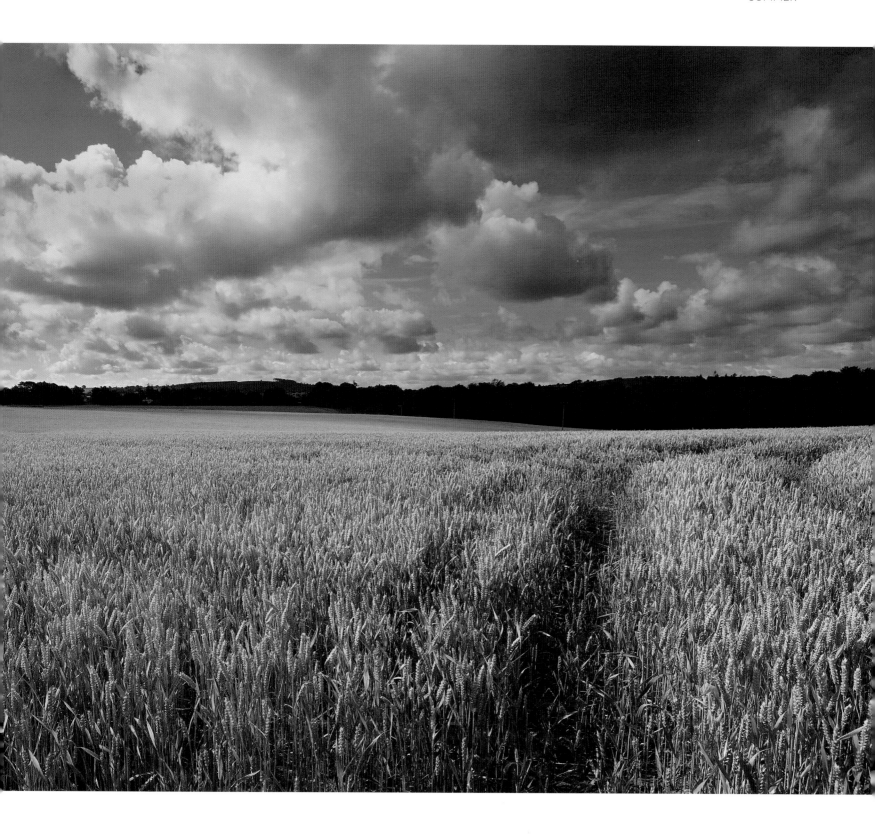

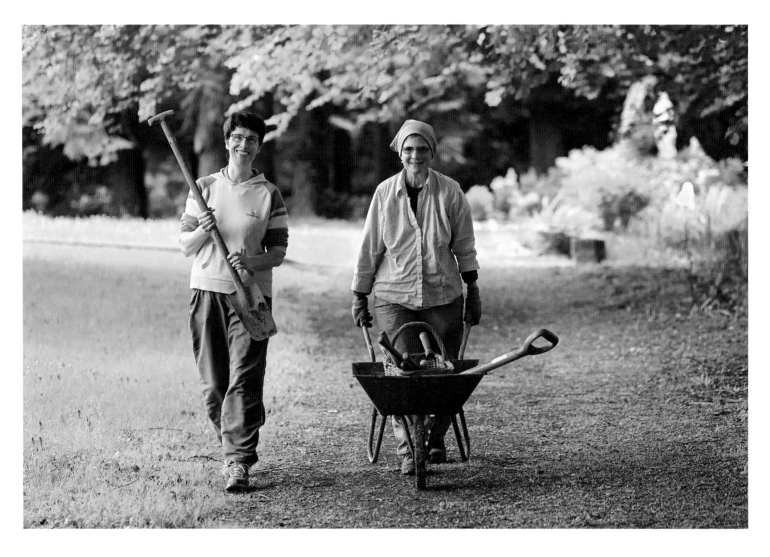

Kate and Sr Denise gather their garden tools after their mornings work
tending to the garden in the abbey grounds at Glencairn.

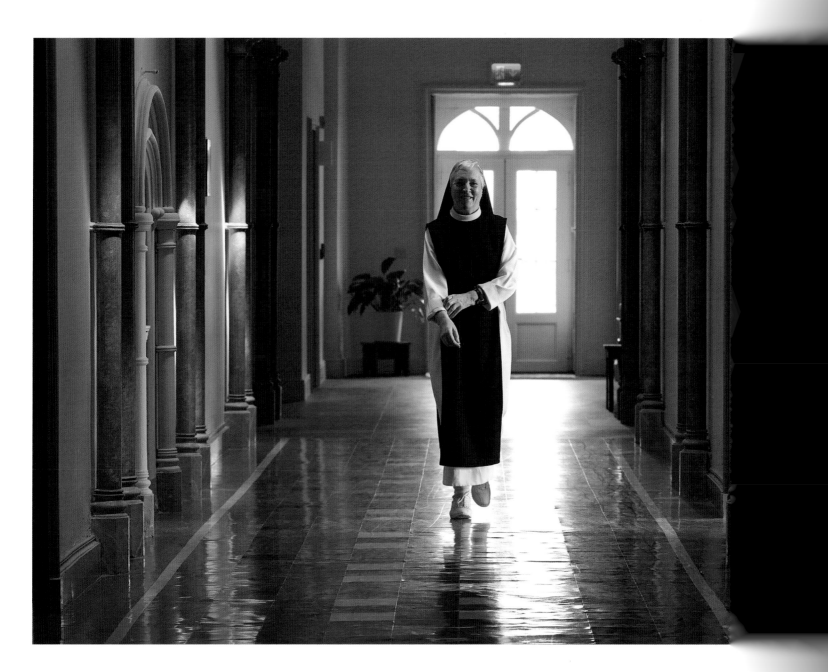

'As soon as the signal for the Divine Office is heard, they must
whatever they have been engaged in doing, and hasten with all s[
but with dignity ... Nothing, therefore, is to be given preference
the Work of God.' (*Rule of St Benedict*, Chapter 43) The work of C
when we gather seven times daily to give praise and thanks to Gc

Mother

VOCATION STORY

I was very young when my family moved to Ballymore Eustace in County Kildare, a lovely village on the River Liffey bordering west Wicklow. That is where I grew up with my three older brothers, Tom, Patrick and Michael. My parents, Siobhán and Pádraig, were from west of Dingle by the sea, Mam from Ballyferriter and Dad from Ventry.

When I was a child I loved the summer holidays. We always went to Kerry during the summer months. I loved those holidays – endless sunny days spent on beautiful beaches – and in the evenings we visited family and friends whom we wouldn't have seen since the previous summer. The conversations were mostly in Irish and full of good humour. I loved the whole place so much. I loved the groundedness of the people and their language steeped in God; the wild rugged and extraordinarily beautiful landscape where our ancestors walked; the sea and Skellig Mhichíl, that mysterious island where once monks lived. It was back then that my soul was first stirred with a deep longing for the Divine. I feel blessed to have been called to monastic life. Life is good here in Glencairn. We rise at ten to four in the morning for Vigils, a very special time of the day. We keep the whole world in our prayer, especially those who may be suffering, those who can't sleep, those who work at night, those who find it hard to face the new day for whatever reason, those we know and love, those who ask for our prayer.

God in his great love and mercy calls each one of us into union with Him in our own walk of life, whatever it may be. St Augustine says in his writings, 'You have made us for yourself, O Lord, and our hearts are restless until they rest in you'.

Sr Maria Thérèse

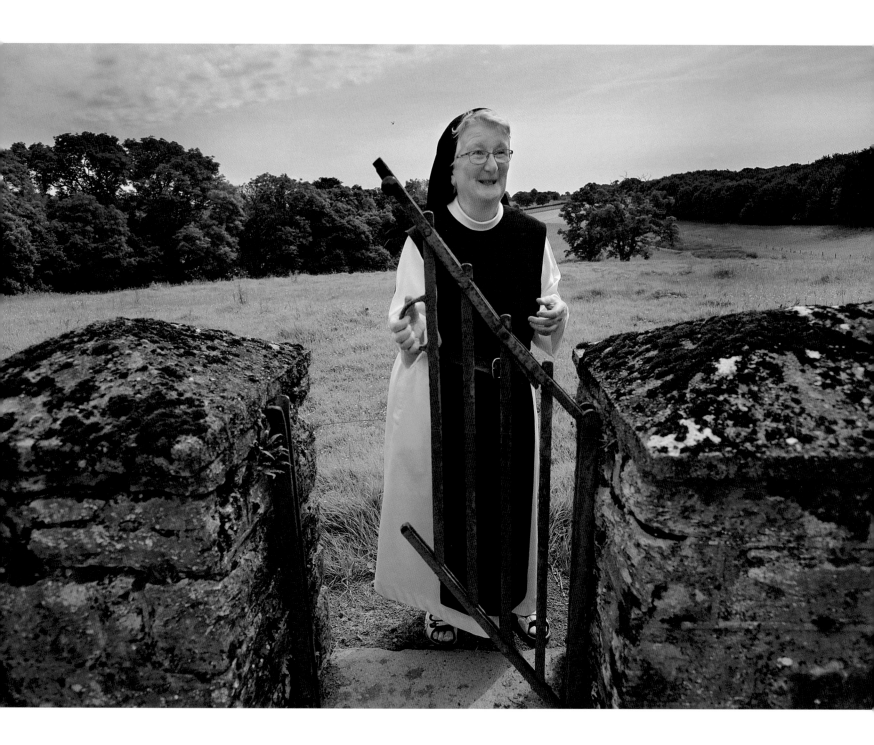

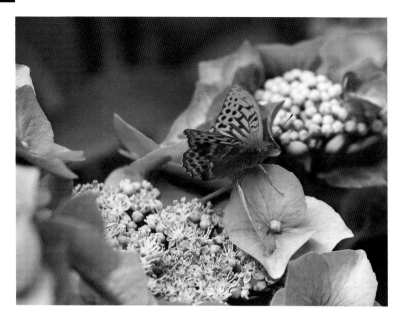

Left: A silver-washed fritillary dances over a Lacecap Hydrangea. In Christianity the butterfly signifies the resurrection, a transformation into new life, a beautiful metamorphosis from egg to caterpillar, to chrysalis and finally to butterfly – a new creation.

Below: Sr Michele pours custard on Glencairn's famous homemade apple tart for visiting Sr Mary Scullion.

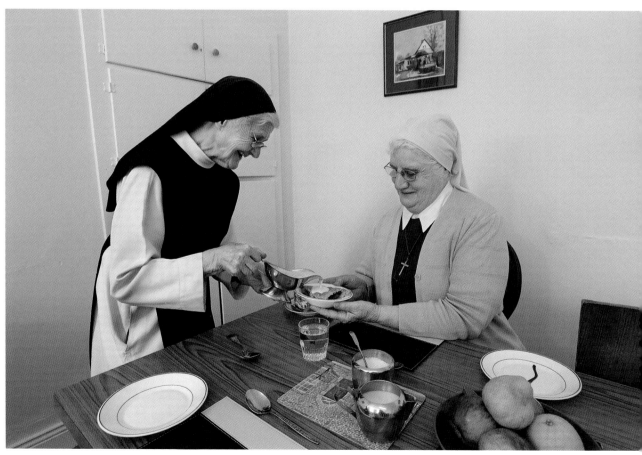

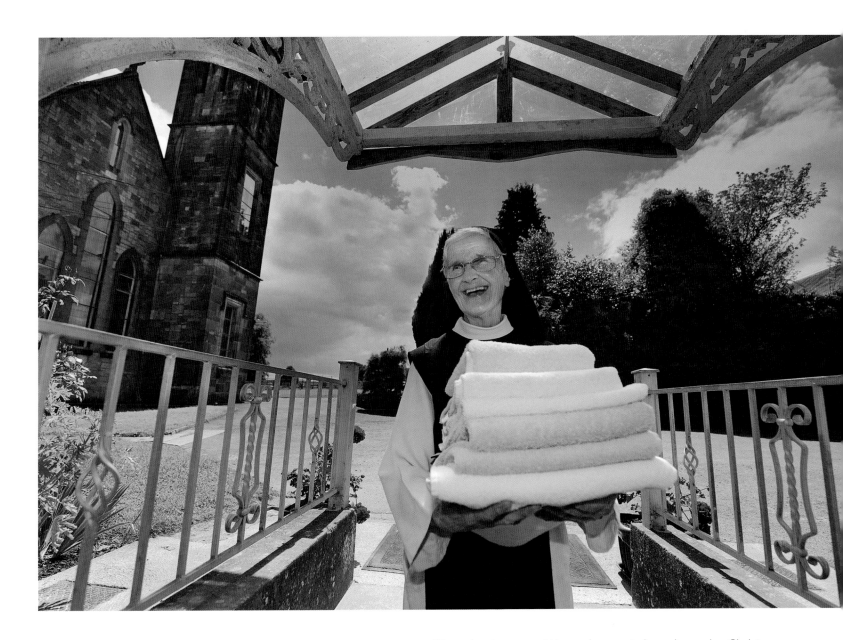

All guests who present themselves are to be welcomed as Christ,
for He himself will say, 'I was a stranger and you welcomed me.'
(Matthew 25:35) Sr Michele is guest mistress at the abbey. She
loves welcoming people and enjoys hearing their stories, while
sensitively recognising their need for reflection and silence.

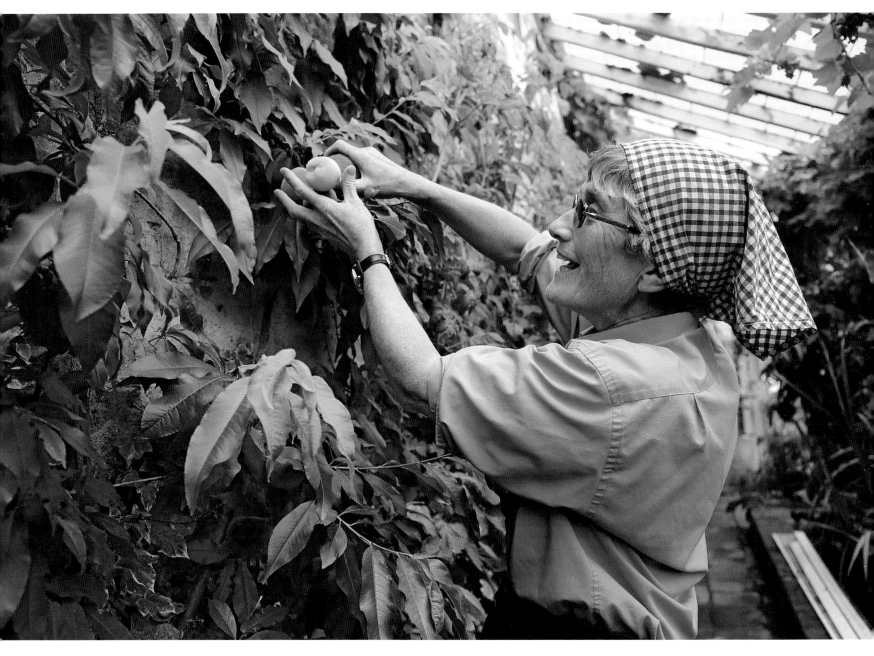

Sr Fiachra anticipating the wonderful flavour of Peach 'Peregrine'. As a horticulturist Sr Fiachra shares her love and enthusiasm of the monastery garden and greenhouse with everyone, imparting a wonderful knowledge of planting, growing, weeding and cultivating the finest peaches, apples and blackcurrants in Ireland.

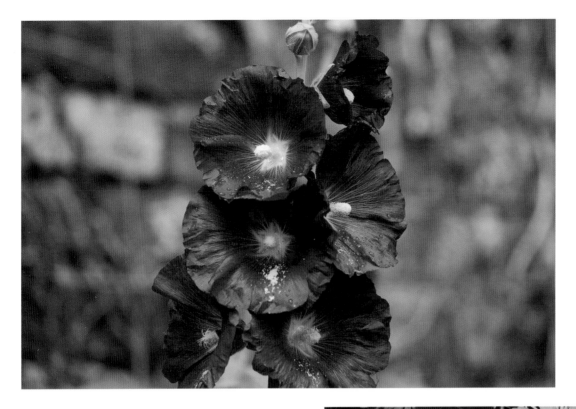

Above: A red Hollyhock, *Alcea rosea* 'Rubrum', grown from seed by Sr Fiachra in the abbey gardens

Right: Aptly named *Leucanthemum* x *superbum* 'Shaggy' it makes a wonderful cut flower for inclusion in the church flower arrangements.

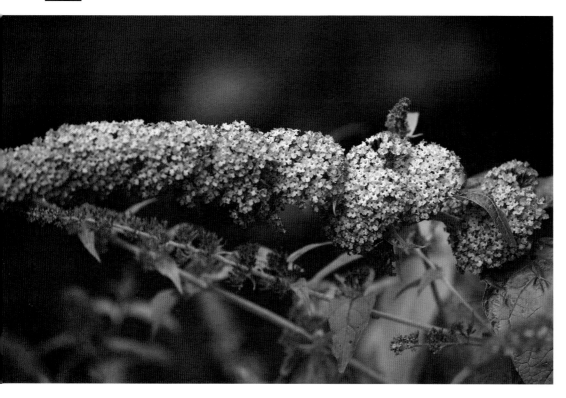

This Butterfly bush, *Buddleja* x *davidii* 'Pink Delight' is so nectar rich that it is frequently covered in butterflies.

We have a hefty blackcurrant crop every year, which we use to make syrup, jam, desserts, etc. all bursting with Vitamin C. Its latin name is *Ribes nigrum* 'Baldwin'.

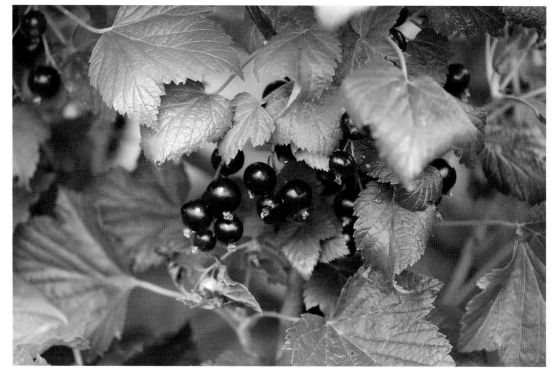

Grapes forming in the vine house in early summer will be ripe for harvesting in September or October.

Peaches have been grown at Glencairn since long before nuns came to live here. Today we have two mature plants, which produce an ever-larger crop with each passing year.

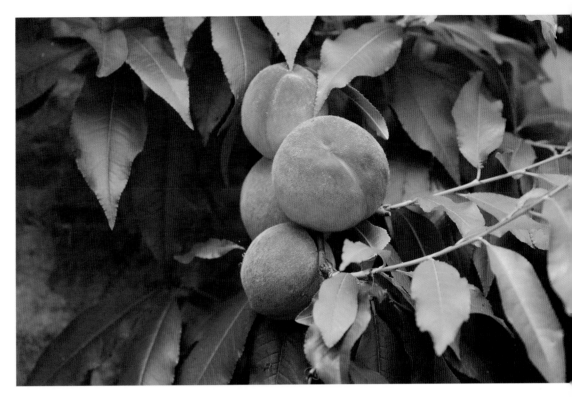

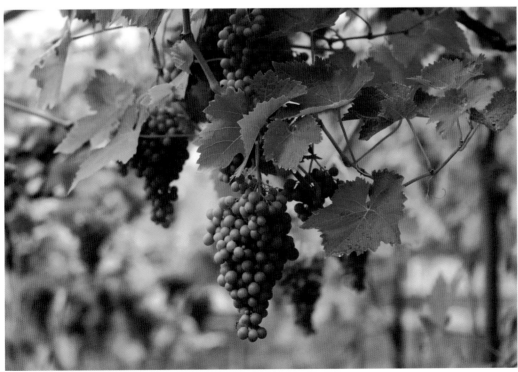

autumn

When the days darken in Glencairn and the warmth ebbs away, the season of autumn naturally gives rise to our contemplation of the mystery of life with its cycle from birth to death. As the trees change colour, displaying marvellous shades of yellow, red and orange leaves, which gradually fall away, we admire their gracious letting go and the beauty of the trees in their stark vulnerability. In autumn the balance of prayer and work goes on in the monastery as the community prepares for the season of Advent and Christmas, lighting up our winter days with the joy of the coming of Christ.

Sr Sarah

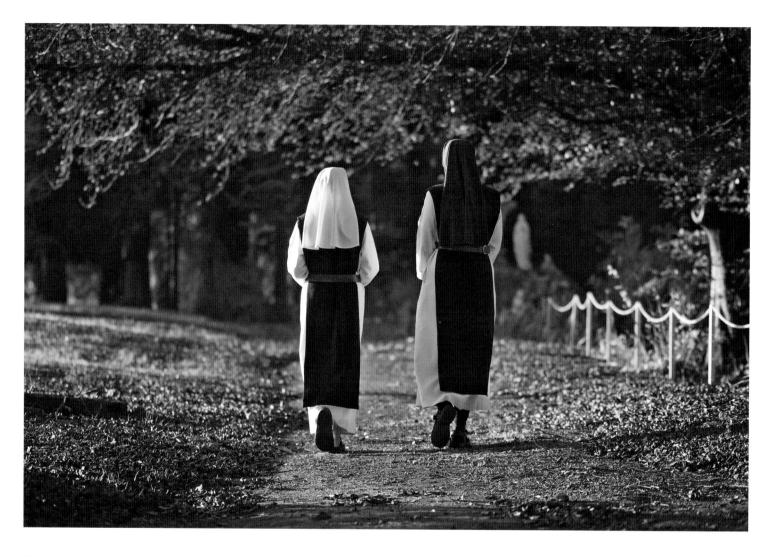

The newcomer to monastic life is accompanied by a wise, experienced sister. This accompaniment continues throughout her formation as she is immersed in monastic life. There is the physical immersion through living the monastic day: the Rule, vows, silence and work. There is the intellectual immersion in Scripture: monastic writers, contemporary writers and monastic theology. And there is the spiritual immersion, the journey to the heart, discovered and enriched through *lectio*, liturgy and prayer. What we are called to is depth, and it is this depth which gives quality to our monastic life.

Mother Marie

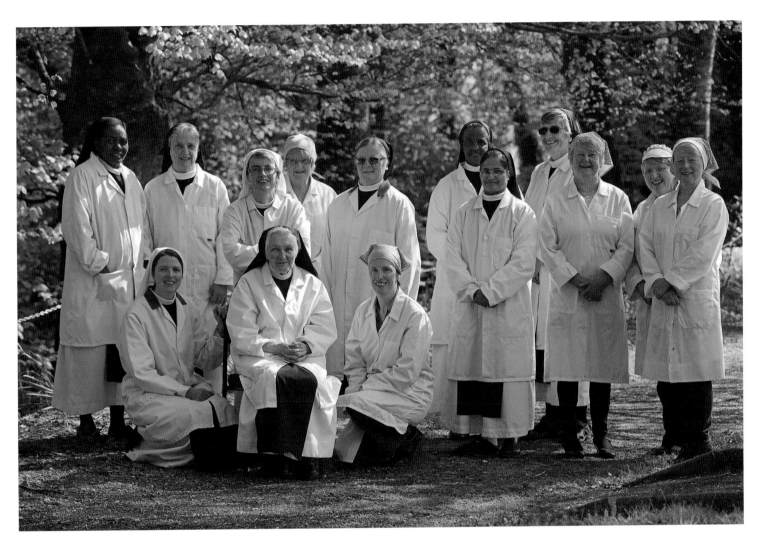

The Eucharist Bread team, included are Sisters Angela, Scholastica, Fiachra, Anna, Josephine, Liz, Ann, Robert Maria, Mother Agnes, postulant Kate and Kay Hogan, Breda Fahey, Sheila Cuddy and Nellie O'Donovan.

Glencairn Eucharist Bread was established as an industry in 1981. It was deemed capable of effectively fulfilling several diverse requirements of monastic life, including the provision of suitable employment for elderly and infirm sisters, who are no longer able to undertake heavy work on the farm or in the garden, but whose prayerful participation in the life of our community is invaluable. Since then the business has grown exponentially so that today, with a database of over four hundred and fifty customers, it makes a significant contribution to the income necessary for the support of our life of prayer.

A vitally important aspect of our industry is its outreach to people beyond our enclosure. At present we supply hosts not only to cathedrals, parishes and other religious houses but also to schools, hospitals,

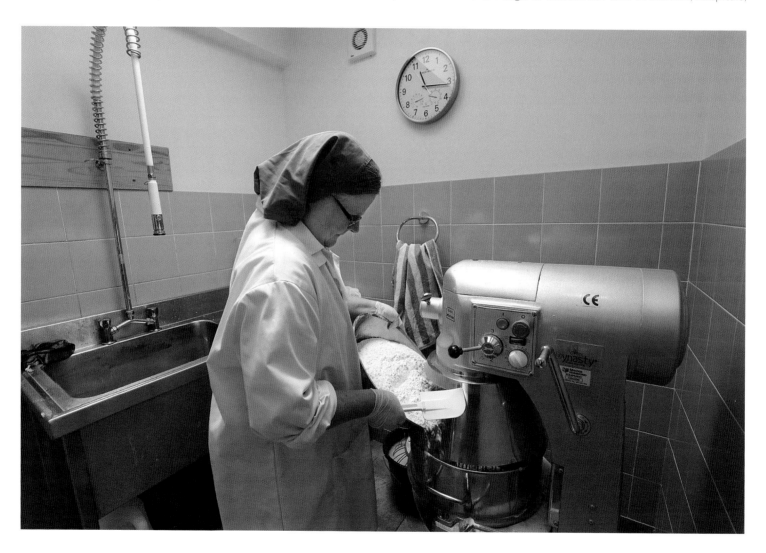

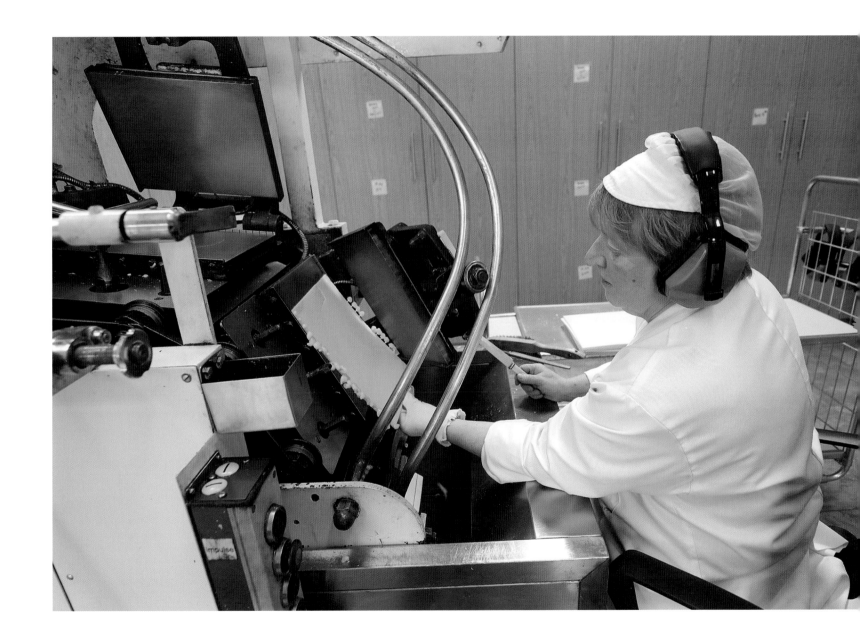

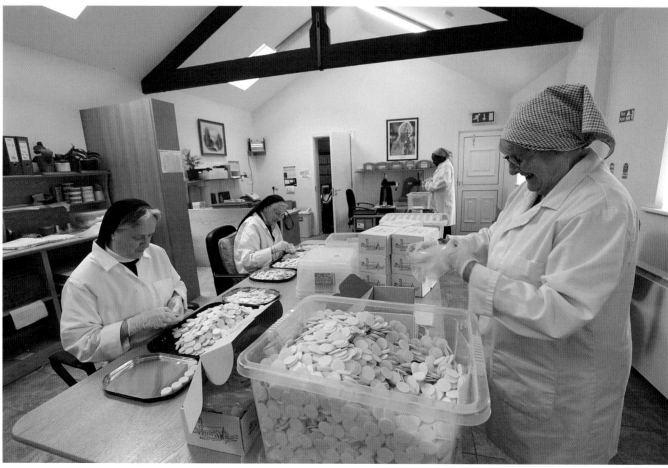

rt4ory

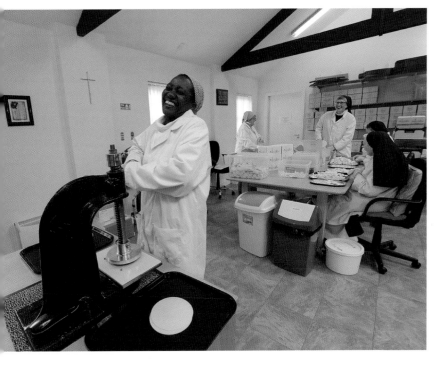

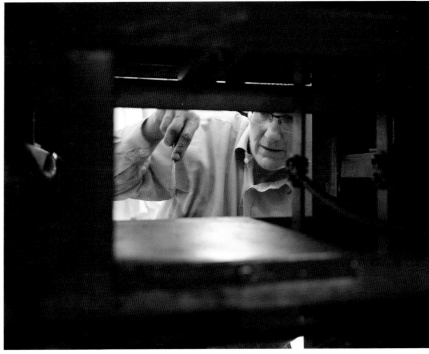

prisons, nursing homes and houses of retreat. The vast majority of these customers are located in Ireland and the UK but we also have a number further afield, including a number of Irish priests, working as missionaries in various parts of the world.

Great attention and precision is necessary during each step of the production process from mixing batter, through baking, humidifying and cutting before we even get to the business of marketing and dispatch. Of course as the business has developed over the years, so too has the legislation which governs a modern food industry. It must conform not just to specific standards of hygiene but which also pertain to the disposal of waste. Happily we have managed to keep abreast of this and are proud that today our commitment to recycling ensures that virtually nothing goes into landfill. This we feel is one of our community's most significant responses to Pope Francis' plea in his encyclical *Laudato Si* to respect and care for our planet.

And finally, hats off in deepest gratitude and appreciation to our team of lay volunteers without whose generous and consistent contribution we would struggle to maintain and run this business, now so vital to the support of our monastery and life of prayer. Thank you ladies!

131

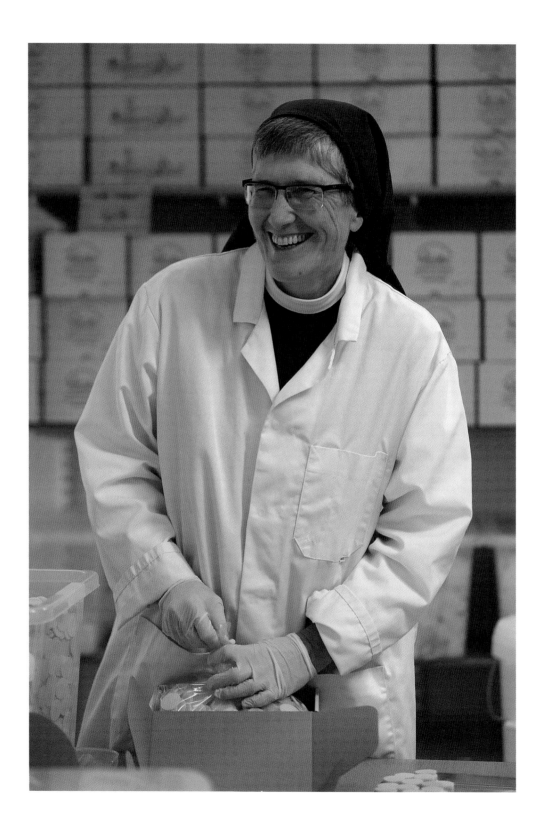

VOCATION STORY

The Road to St Mary's Abbey, Glencairn

'What in the world would make you want to join an enclosed order?' It's hardly surprising this was one of the most frequent and utterly dumbfounded reactions when I broke the news of what I was about to do. Being the only girl of four children, I was an outstanding tomboy in my early years and was rarely, if ever, seen in anything but trousers or shorts.

Despite having achieved a good Leaving Certificate at the age of sixteen, I was unable to enter university because I was too young. Instead I travelled to Orléans in France, where I spent a full year as a trainee in a wholesale nursery. When I returned to Ireland, my eldest brother, who had completed a degree in business, and I joined forces in running our small family business. We worked well together for almost twenty-two years and our joint efforts culminated in a thriving retail garden centre. Years later I attained a BSc in horticulture at Writtle College in Essex and accepted a managerial position in a garden centre in the beautiful town of Saffron Walden just outside Cambridge. There

I was warmly received into a small but vibrant parish. However I could no longer ignore the persistent idea of a religious vocation. I attended a monastic experience in St Mildred's monastery in Kent. It was during my four days there, in the autumn of 2005, that I had a very intense experience of God as I had never previously known Him and I knew then that I had to pursue this calling.

On 3 January 2006 I came to Glencairn for three weeks to experience the daily rhythm of monastic life as lived by the community. It eventually became clear that really this was the life God wanted for me and on 6 August of that year, I entered as a postulant.

I still marvel at how God brought me here and gave me all the graces, help, courage and strength I needed, not just to enter Glencairn but to complete my time as a postulant, novice and junior professed sister. On 30 August 2012, with great joy and peace and in the presence of family, friends and community I made solemn profession – the happiest day of my life.

Sr Fiachra

Traditionally bookbinding was practised in monasteries from early medieval times. In fact many of the techniques now used were actually first developed in monastic workshops. The laborious and solitary copying of biblical text became an important part of monastic life, spreading the Christian message in Europe.

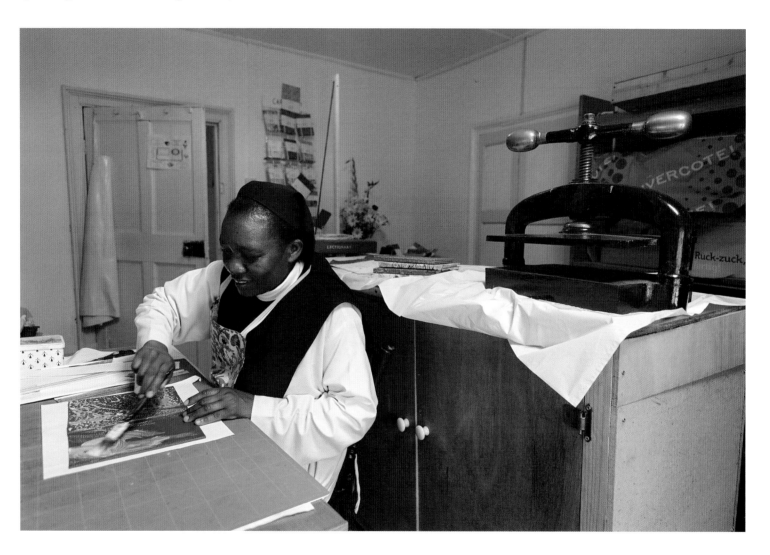

One of the big pluses of living in Glencairn is being able to witness the changing of the seasons. Our lives are illustrated through the seasons of liturgy and nature. Becoming evermore immersed in these cycles year by year brings an unending source of joy

> ❝ 'I see his face in every flower,
> The thunder and the singing of the birds
> Are but his voice, and carven by His power,
> Rocks are his written words.' ❞
> (Joseph Mary Plunkett)

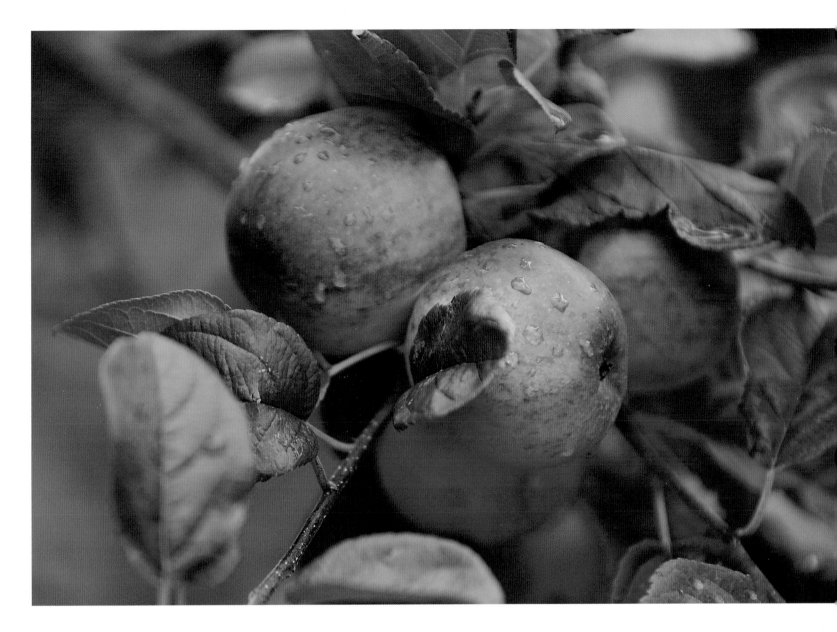

In our orchard we have fourteen different varieties of early, mid and late
season apples, both culinary and eating and thus much to look forward
to from September on.

Sr Fiachra

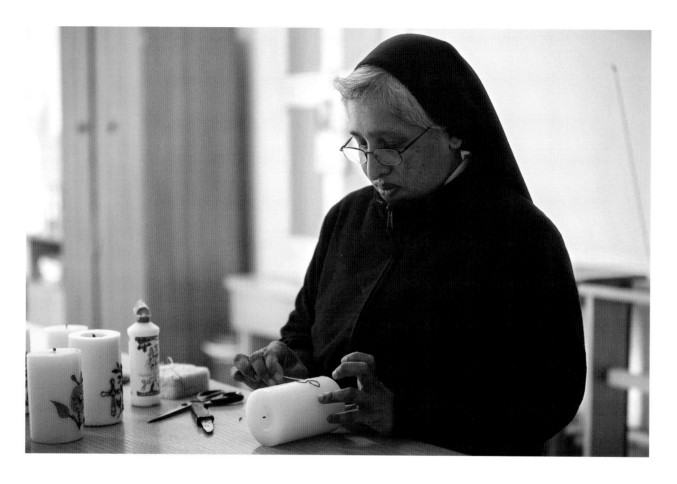

Sr Stephen hand painting candles. Sisters Stephen and Scholastica make various types of candles for every occasion – Christening, Holy Communion, Confirmation, Wedding and Memorial. They are made to order on a small scale and some are sold in our shop. Different types of wax, including re-cycled wax, are melted in a container and poured into the various moulds with cotton wicks threaded and secured. When the candles are fully cooled, they are individually hand-painted with flowers and other decorations.

Sr Stephen

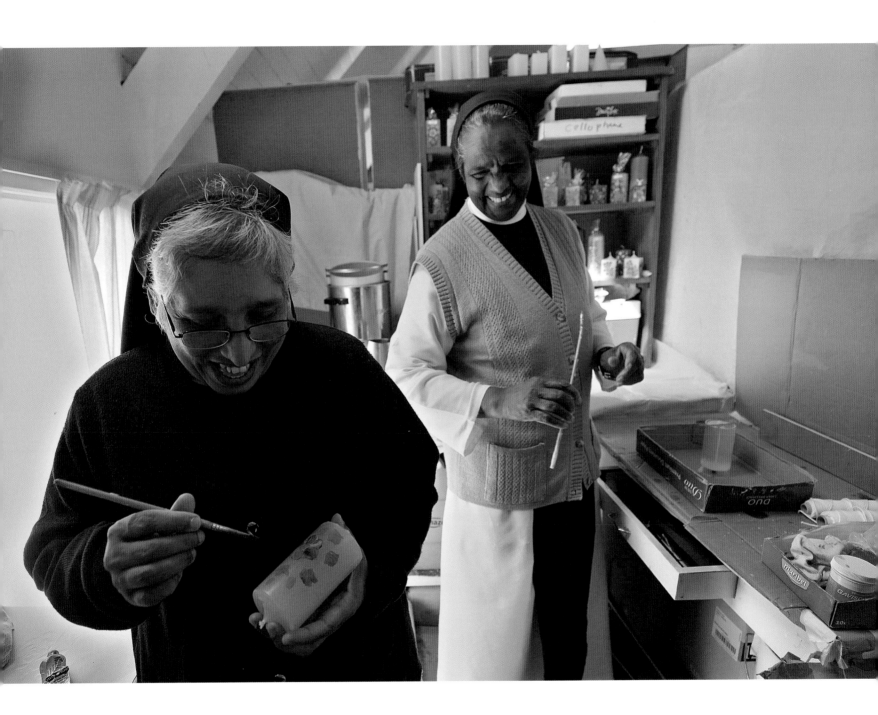

Left: It is in the chapter room that the weekly duties are read out on a Saturday morning and all the duties change at first Vespers for Sunday. The duties include reader at the Eucharist, reader in the Refectory, servants of the refectory and server at the Eucharist. There are also various choir duties, which rotate through the community from week to week.

Opposite: The postulant is welcomed in the chapter room. It is here that the novice is clothed in the Cistercian habit and it is here that two years later the novice professes her first vows.

Mother Marie

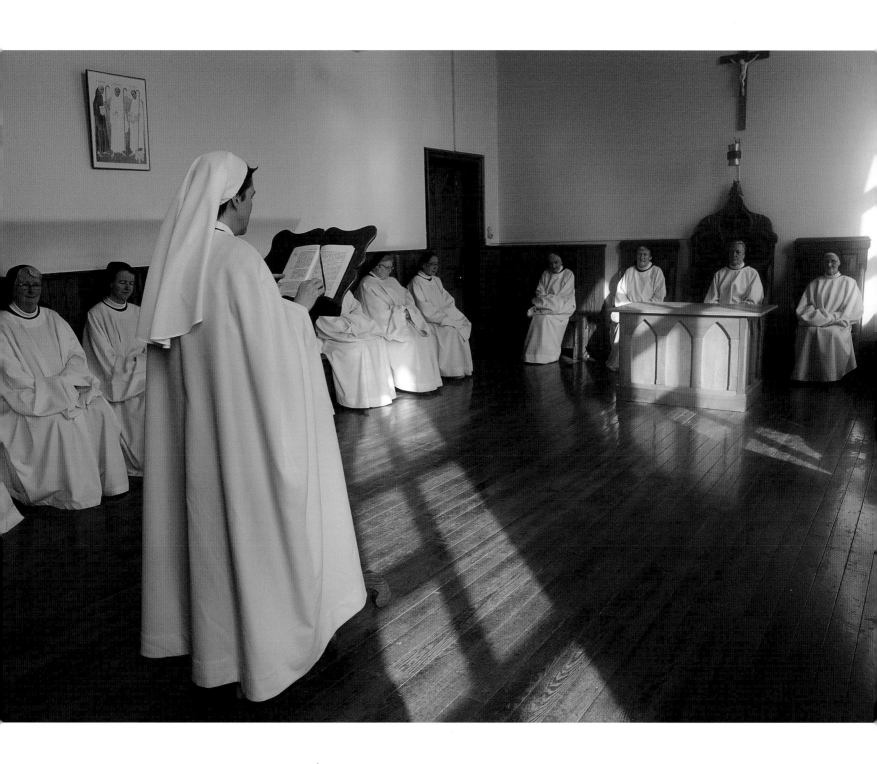

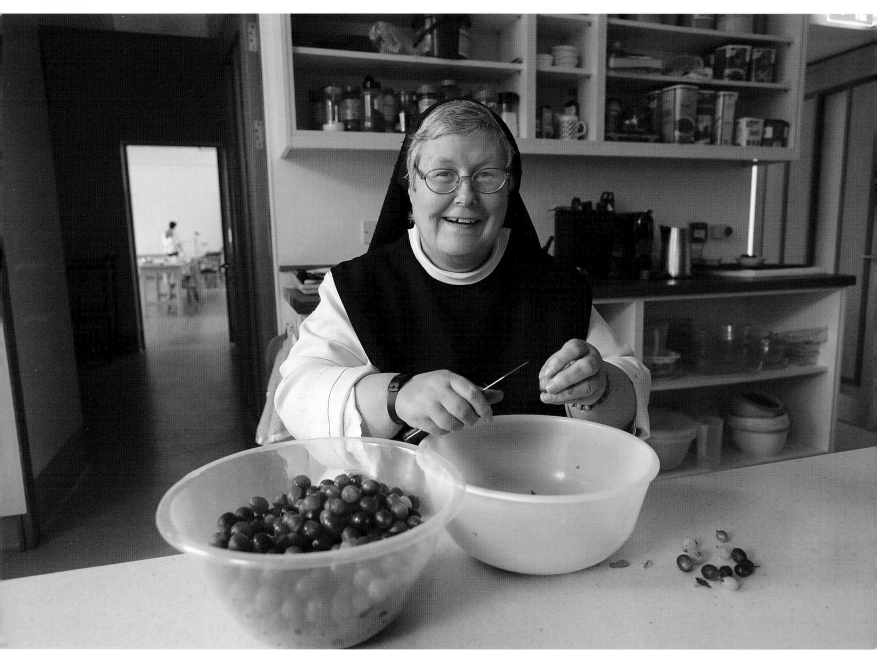

'You will eat the fruit of your labour.' (Psalm 128) In our monastic garden there are two varieties of gooseberries, the green sour ones and the sweeter red ones. Sr Nuala tops and tails red gooseberries to ready them for Liz to bake her beautiful gooseberry tart for the community. It might be a mundane task if it did not provide the opportunity for silent reflection.

Sr Nuala

'The land yields its harvest; God, our God, blesses us.' (Psalm 67) Onions drying in the open air in autumn. After about two weeks of drying they can stored and used for cooking throughout the autumn and winter months.

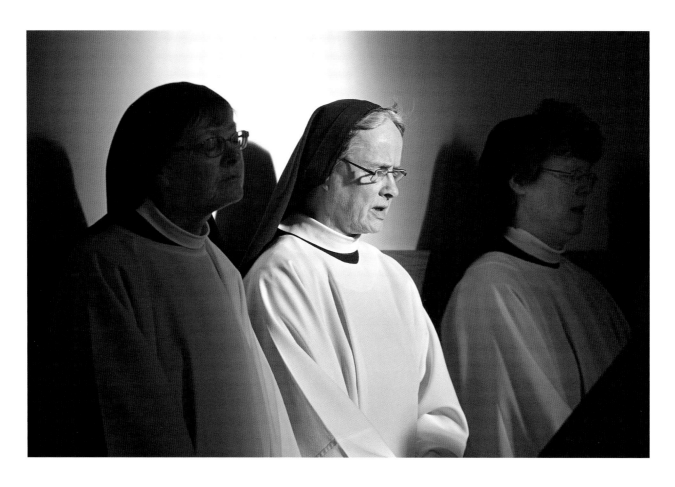

We give thanks, as day draws to a close in the evening prayer of Vespers,
for all that this day has brought and for the events of our salvation.

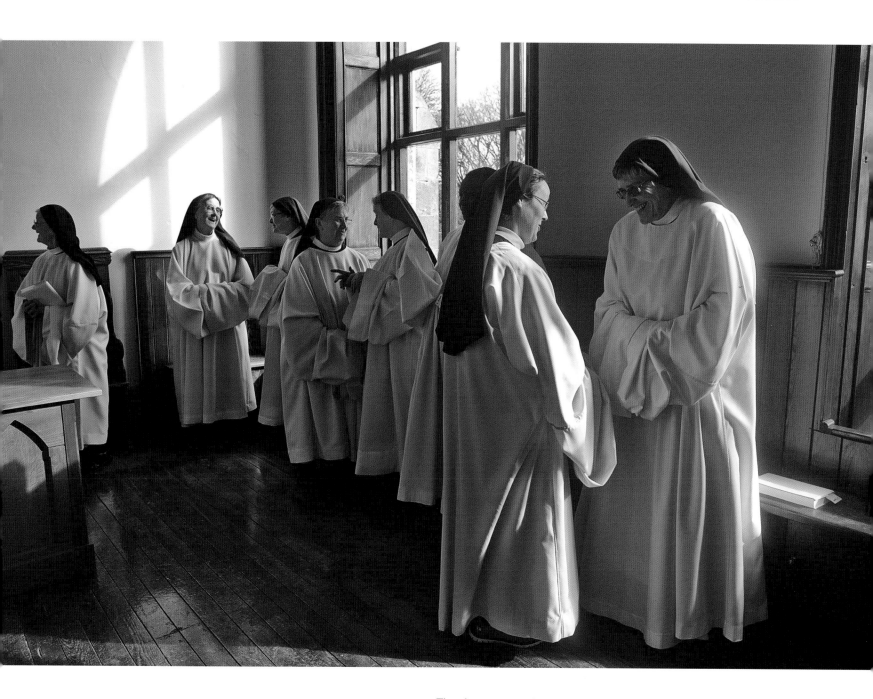

The chapter room is very central in the life of a monastic community. We gather here each day to listen to the *Rule of St Benedict*, to hear the Abbess' chapter talks and to share what is happening in the life of the community.

Mother Marie

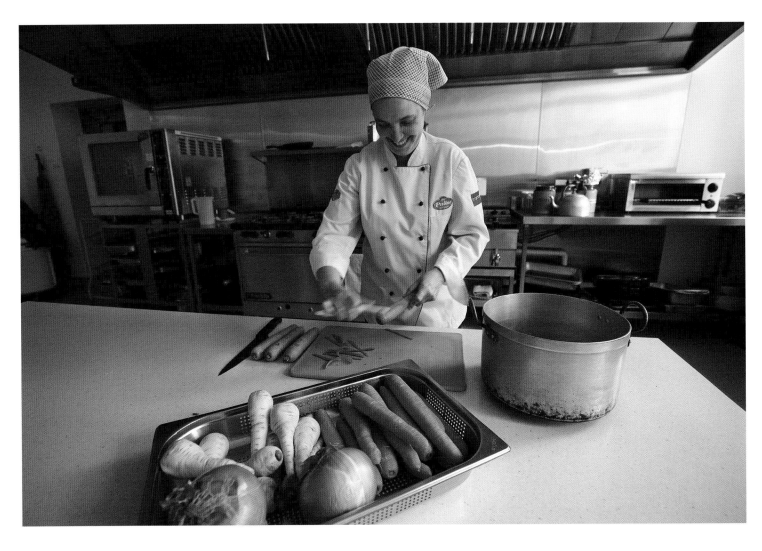

The monastery kitchen is a busy place. We constantly try to provide a diet that is Cistercian (vegetarian), nutritious and varied. We also cook for guests. Liz, our wonderful cook, who works Monday to Friday has kept us fed with beautiful food for many years. It is especially satisfying to be able to cook with food that we have grown ourselves.

We eat in silence. Breakfast and supper are pick-up meals but for lunch we say grace together and listen to a reader while we enjoy our food. For St Benedict moderation is the ideal – not too much, not too little.

Festive days are always highly appreciated especially if they happen to occur during Lent.

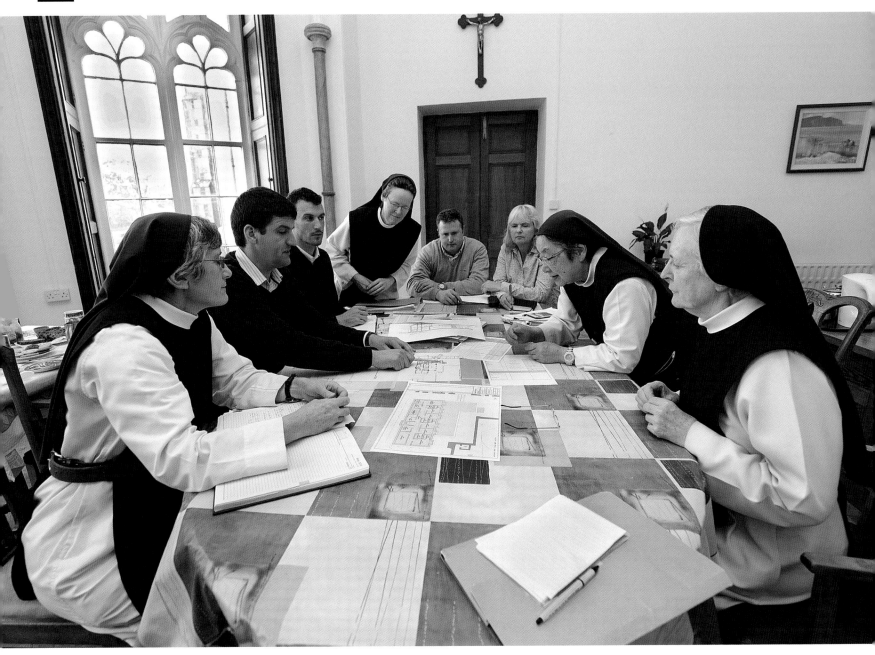

Our building and finance committees meet regularly with Quinn Architects and the design team. Though the meetings are sometimes challenging the end result is always just right and beautiful. Included here are Cathal Quinn, Bernie Moloney and Mark Kileen (Quinn Architects), Ciaran Mc Carthy (quantity surveyor), Sisters Fiachra, Michelle, Clothilde and Mother Marie.

Lectio Divina is a process of spiritual reading, slow, meditative, listening and responding to the word of God, alone or with a group. It is fundamental to the monastic life of prayer, together with the seven hours of prayer time at the abbey. Sr Denise reads in the quiet of her bedroom.

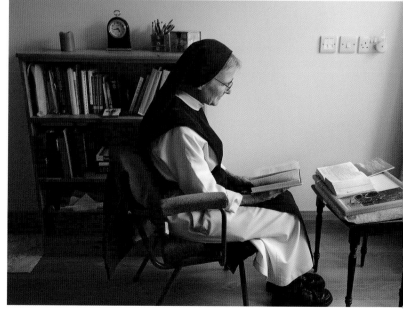

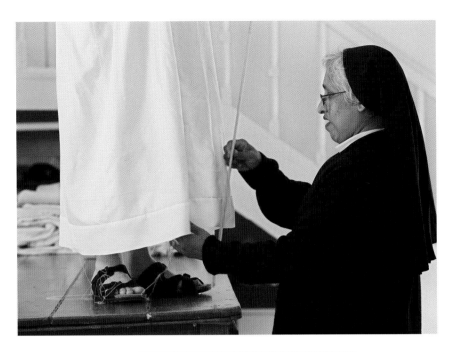

I'm sure it would really surprise people if they could see our very low budget clothing department that caters for twenty-nine women. We make all our own clothes and do all of the mending. Nothing is wasted; everything is recycled. The sewing room is a very busy place and one needs much patience and creativity to work here.

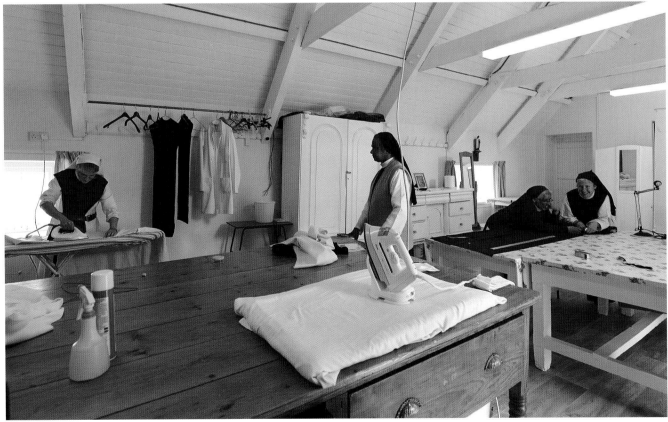

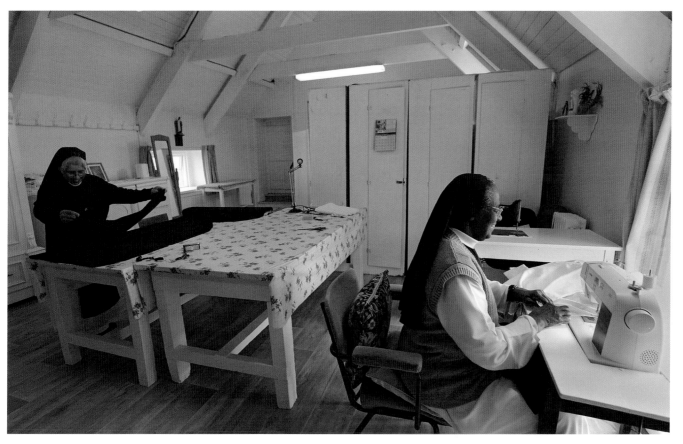

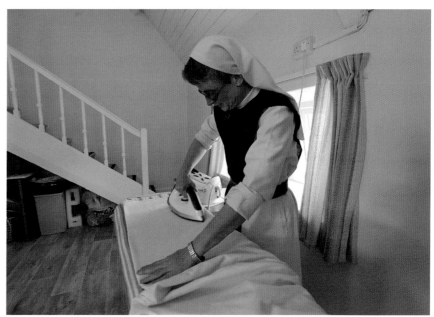

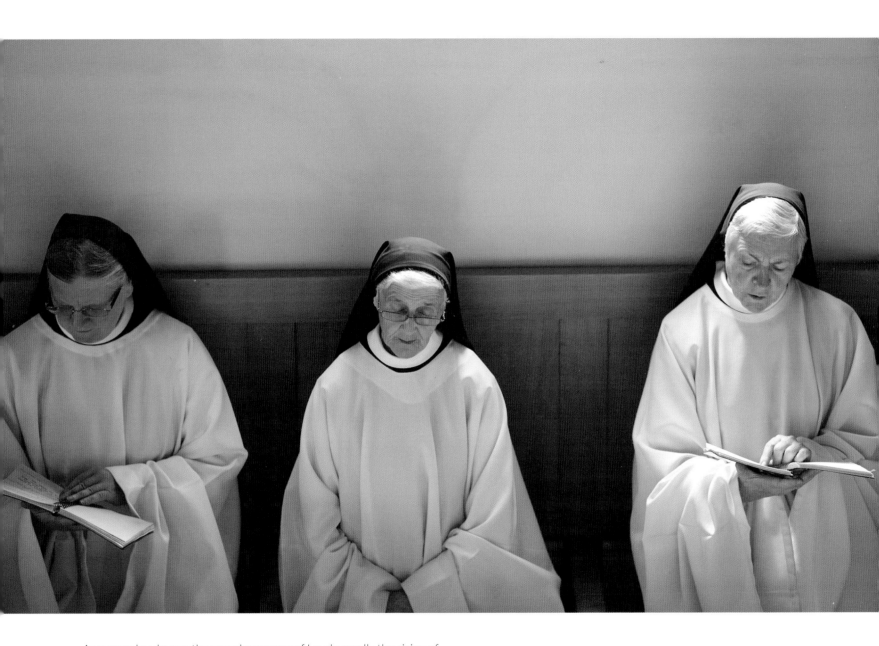

As a new day dawns, the morning prayer of Lauds recalls the rising of
Jesus Christ, in whom we celebrate, 'the true light, that gives light to
everyone.' (John 1:9) The psalmody of Lauds consists of one morning
psalm, followed by an Old Testament Canticle, and a second psalm which
traditionally is one of praise.

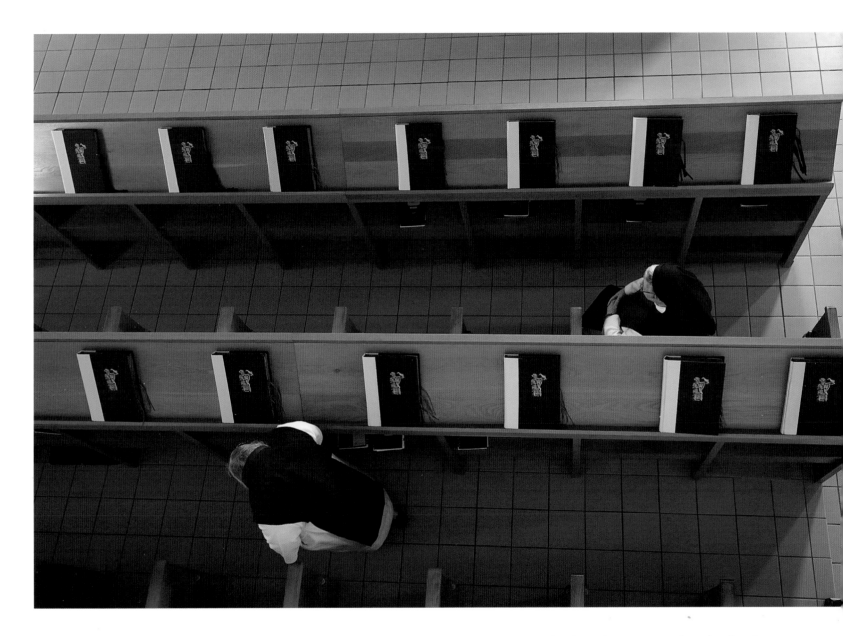

Our Office is seven times a day. Sometimes we come into the church between these times for quiet, a bit of space, to be alone while not being alone, to breathe in the stillness of Presence. The stalls are a place of praise and of discipline.

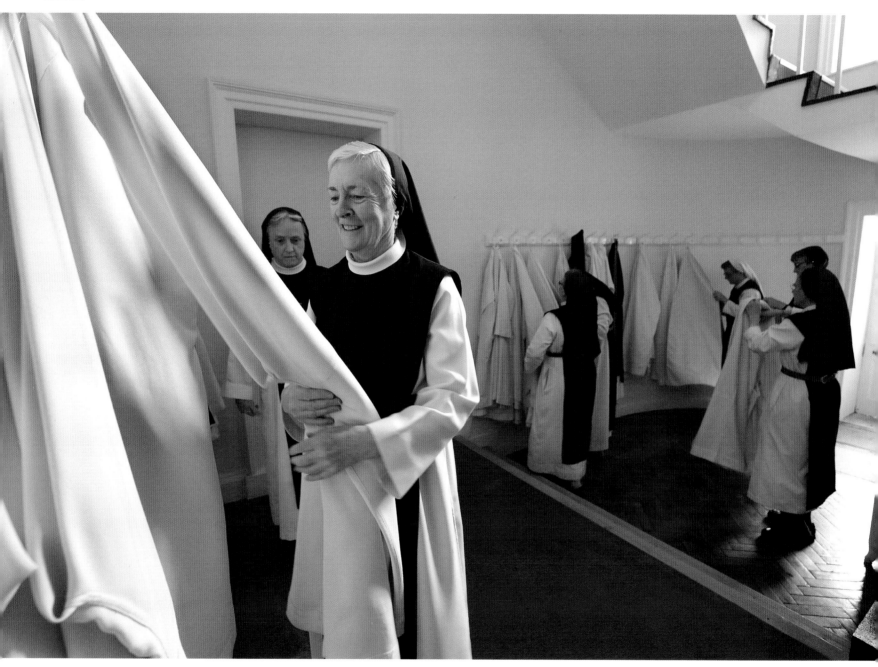

Exterior ritual, dress, comportment does help our interior worship. Wearing cowls is important; moving quietly, not rushing, stillness while in choir helps us to remain present, a loving presence to the Lord and to each other. Rituals like kneeling, walking in ceremony and discipline makes us aware and attentive to the sacredness and dignity of our worship and prayer.

Mother Marie

VOCATION STORY

A Delayed Vocation

For as long as I can remember I wanted to be a nun, but I never told anyone because I was afraid I would be laughed at. I had three sisters and one of us would have to stay with our parents. My father had left his right arm, from the shoulder, behind him on a battlefield in Belgium in World War I. Pensions were small and if he died before my mother his pension died with him.

Two of my sisters, one older and one younger, went to England to train as nurses, and the youngest, Nan, and I were left at home. I had trained as a teacher and got a job near home and I made up my mind that as soon as Nan had finished school and got a job, I would enter a convent. Then came the bombshell. One day, a few months before she did her Leaving Cert, Nan announced that she was going to enter the order of St Joseph of Annecy in Wales, where our mother's sister was a nun. My world was in bits at my feet, but still I said nothing.

Before Nan entered the convent the two of us went on a holiday together. We spent a few days in Mount Melleray, where we had a friend, Fr Killian Walsh. We attended the Divine Office every day in the visitor's gallery at the back of the church. During the Office, in some mysterious way the Lord made it known to me that this was the only life that would make me happy on this earth. When the morning came to leave Mount Melleray my heart was broken, but still I never mentioned it to anyone. Nan entered the convent and is still very happy there.

That was in 1951. In the mid-1950s I began to wonder what my own chances of becoming a Cistercian nun would be and I came to Glencairn to discuss the situation with the Abbess, Rev. Mother Gertrude Purcell. She listened to my story and her advice was, 'Go home and look after your parents and when they are gone come back, and if God wants you to be here you will be here'. The years went by. My father died in November 1972 and my mother in September 1979. Although I knew I was now free to pursue my Cistercian vocation, my heart was broken. On Vocation Sunday 27 April 1980, I wrote to the Abbess, Rev. Mother Imelda Power, and asked if she would consider taking me as a postulant. I was overjoyed when the reply came, 'Your age is against you, but we will give you a chance. Come and see me some day and we will talk about it'. On Sunday 2 November 1980 I entered as a postulant.

Monastic life has had its ups and downs, but with the help of the Lord who called me here and of Our Lady, patroness of our order and of our monastery, I managed somehow to keep going. Now, at ninety years of age, I look back on my long life with gratitude in my heart for my parents, my sisters, my relatives and friends and above all for my monastic vocation. I can honestly say that monastic life is the nearest approach to heaven on earth – if a person truly has the vocation, the call from God and the faith to answer.

Sr Kate

VOCATION STORY

I am from the town of Longford. My family was a traditional Irish family. There are six of us, three boys and three girls. Both Mam and Dad were practising Catholics.

I got all my school education from the Mercy Sisters. I had a good relationship with my teachers; some of them are in touch with me to this day, and they come to visit me here in Glencairn every year. After my Leaving Cert I did a commercial course, and began working in the civil service in Dublin. While I enjoyed life in Dublin, deep down in my innermost being there was a thirst for something more. I visited Glendalough quite often at weekends and found great peace there.

About this time a friend and I attended a Viatores Christi (an Irish lay missionary movement) information day, which I found very informative and interesting. After doing the training course for a year, I was assigned as a hospital administrator to a small bush hospital run by the Medical Missionaries of Mary in Nigeria. There were many Irish missionaries in Nigeria at that time, and there was always great camaraderie among the missionaries, both lay and religious. Hospitality is a given in all missionary territory; you welcomed every missionary on the road who called to your house, and in turn you were welcomed in their compound if you were travelling their way, and you gratefully accepted whatever hospitality was offered.

Shortly after I arrived in Nigeria I went to visit an enclosed order of nuns, St Justina's Monastery, Abakaliki, a foundation of St Mary's Abbey, Glencairn. As it turned out I was to be a regular caller to the monastery for the next two years. I attended Mass at the monastery quite often on Sundays and would have a chat with the superior. She would often talk about life in the monastery and about the monastery back in Ireland, Glencairn. I felt drawn to this way of life, and so the seed was planted.

In early 1985 the superior of the monastery in Nigeria was home on leave in Glencairn, so I got in touch with her and asked if I could visit. She agreed and so I came and met her. It was on this visit that I told her that I felt that I was called to this life.

My first live-in was in Holy Week, 1985.

I entered Glencairn 3 October 1986.

Sr Ann

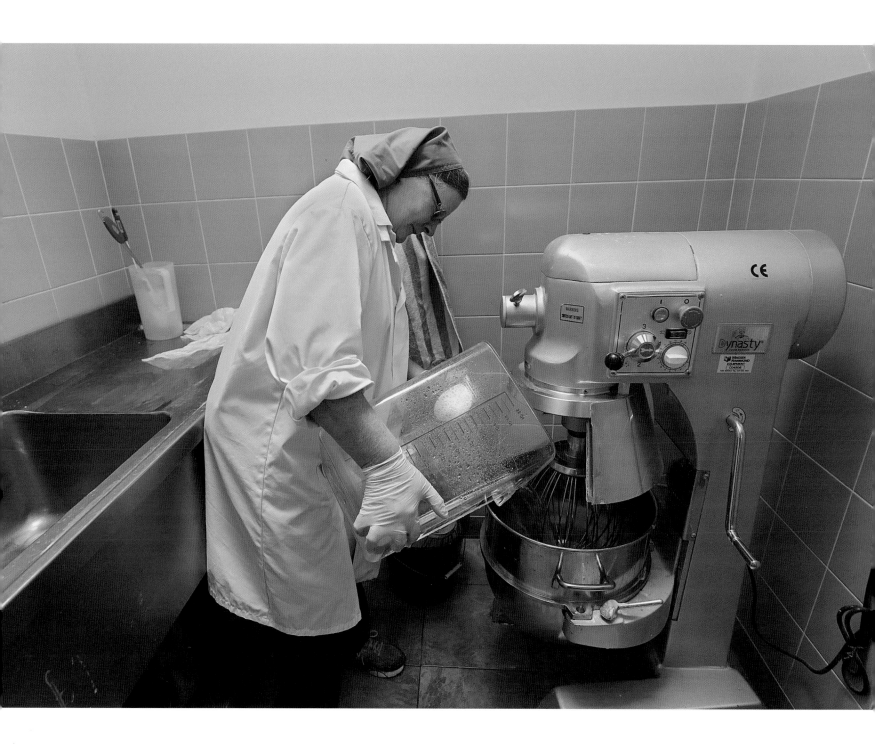

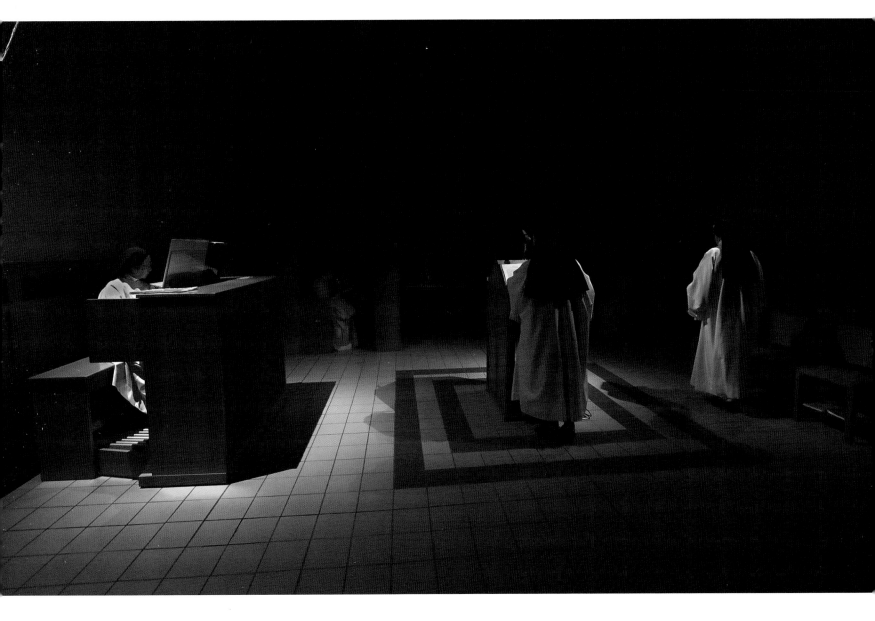

Vigils, at 4:10 a.m, is the first Office of the day. To keep vigil is to be in a state of watchfulness, awakeness. When we are awake, when we keep vigil we are accompanying others. We join with the whole church to sing the psalms, listen to the Scriptures and lift up all people to God's mercy and care. When we keep vigil we participate in watching with God to protect our hearts and our turbulent vulnerable world from the forces of evil. It is also an alert waiting for the dawn, a heart open to God's Word, a longing for the coming of God's kingdom.

Mother Marie

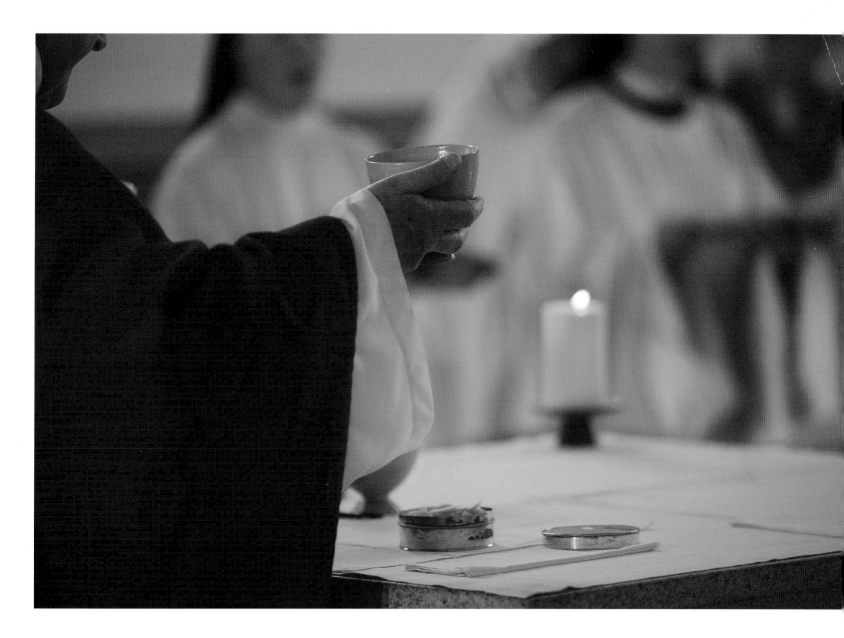

We gather each day for the Eucharist. From God through Jesus to us – a unique communion is transmitted in the Eucharist. Our lives and world are transformed through the transformation of the gifts of bread and wine.

Mother Marie

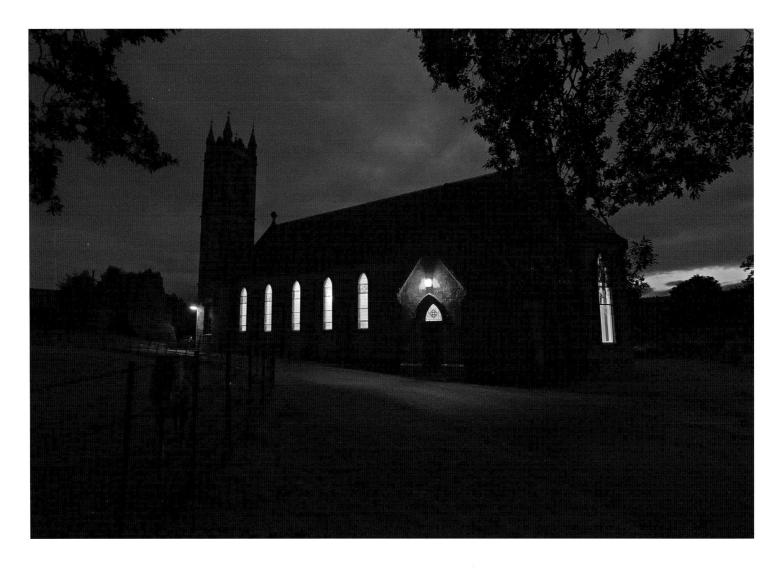

This is the final Office of the day often punctuated with yawns! The word comes from the Latin *completorium* meaning completion. This prayer completes the day. With confidence we entrust ourselves to God's merciful love for the night. This prayer, however, is not just for ourselves; the praise and thanksgiving, the expressions of confidence and hope, the cries of distress and appeals for help rise to God on behalf of all who live. The psalms of Compline (Psalms 4, 90 and 133), which are the same every night, express strong trust in God's steadfast and powerful protection.

The end of each day is a reminder of, and a preparation for, the end of our lives. Our desire is that when the time of our death comes, we too will peacefully and without fear step forward into the infinitely loving embrace of God. We also ask this grace for those who will die that night. After the final prayer and blessing we turn to Mary, the Mother of God, and invoke her in the traditional prayer, *Salve Regina*. (Hail, Holy Queen) She who is 'our life, our sweetness and our hope', will also watch over her children while they sleep.